Praise for *Just Making*

"One of the essential joys of reading is finding that 'yes!' on the page, that 'aha!' Nothing is better than encountering that anecdote, that thought, that idea with which you resonate deeply. If you are a creative, you'll discover many such moments tucked between the covers of *Just Making.* There are whole libraries of how-to books dedicated to craft-building, and to the pursuit of commercial success as a creative, but fewer that lean into the necessary steps to secure what is good, what is healthy, what is healing for the artist's heart. This is one such book . . . As creatives, we must fortify ourselves daily if we're to survive the journey. Perkins suggests intuitive perspectives and practices that can guide us. Readers will thank her for them. I certainly do."

—Nikki Grimes, bestselling and award-winning
author of *Ordinary Hazards* and other books

"By inquiring into the relationship between the making of art and the performance of justice, Mitali Perkins foregrounds questions that any serious creative has to grapple with. By identifying and clarifying the kinds of questions that need to be asked about that relationship, and by setting them in such a winsome and vulnerable and engaging form, she has done those serious creatives an enormous service. This is a book to be read with gratitude."

—Gary D. Schmidt, Newbery Honor and Printz Honor
author of *The Wednesday Wars* and other books

"*Just Making* is a balm to every soul wrestling with how to pursue beauty in a weary world. With tenderness and wisdom, Perkins compassionately reminds us that our art is not separate from justice but intertwined with it. She offers a compassionate commissioning for us to make art justly, love mercy, and walk humbly with our God. This expansive offering of hope reminds us that in the work of our hands, we hold a sacred call to co-labor in the renewal of all things. I needed this book."

—Kayla Craig, author of *Every Season Sacred* and *To Light Their Way* and creator of Liturgies for Parents

"Mitali Perkins is an exceptional teacher and writer, and in *Just Making*, she brings her immense gifts and wide experience together in a book that is both rich in ideas and pragmatic in application. In engaging, accessible prose, *Just Making* provides theological and practical insights to give readers ways to understand that creativity—in all its forms—is not a luxury or a move away from a faithful life, but deeply connected to justice and shalom."

—Dr. Jennifer L. Holberg, chair of Calvin University English Department and author of *Nourishing Narratives*

# JUST
# MAKING

# JUST MAKING

## A GUIDE FOR COMPASSIONATE CREATIVES

## MITALI PERKINS

Broadleaf Books
Minneapolis

JUST MAKING
A Guide for Compassionate Creatives

29 28 27 26 25 24          1 2 3 4 5 6 7 8 9

Library of Congress Cataloging-in-Publication Data

Names: Perkins, Mitali, author.
Title: Just making : a guide for compassionate creatives / Mitali Perkins.
Description: Minneapolis : Broadleaf Books, [2025] | Includes
  bibliographical references.
Identifiers: LCCN 2024036254 (print) | LCCN 2024036255 (ebook) |
  ISBN 9781506485539 (hardcover) | ISBN 9781506485546 (ebook)
Subjects: LCSH: Art and social action. | Creative ability.
Classification: LCC NX180.S6 P447 2025  (print) | LCC NX180.S6
  (ebook) | DDC 700/.4556—dc23/eng/20240919
LC record available at https://lccn.loc.gov/2024036254
LC ebook record available at https://lccn.loc.gov/2024036255

Cover illustration and design by Kimberly Glyder

Print ISBN: 978-1-5064-8553-9
eBook ISBN: 978-1-5064-8554-6

Printed in India.

# CONTENTS

# INTRODUCTION

I'M SITTING IN a small study, drafting a scene in my next novel. Staring at my computer screen, I deliberate for a long while among four nouns. Which evokes a truer sense of place and character? I insert a noun into the story, read the paragraph aloud, reject it, and then try another one. After a while, I work on some verbs.

Time speeds by. As I head to bed that evening, I think once again of Oscar Wilde's famous quote about the writing life: "In the morning I took out a comma, but on mature reflection, I put it back again."

Elsewhere on the planet, during the hours I spend pecking at my keyboard, children carry buckets of water long distances to slake their own and their families' thirst. War rages, shredding land, buildings, and people. Refugees flee across borders, desperate for safety. Women balance loads of bricks on their heads to eke out a living. Unhoused families huddle in tents on sidewalks not far from my warm home. Young people are bought and sold to fatten the pockets of the powerful.

Isn't it selfish to stay in the solitude of my study and generate stories? Why should I keep making art when suffering, injustice, and oppression are wreaking havoc on the planet? Why should you? How does one sustain a creative life given

the seemingly selfish investment it takes to make beautiful things? Our gifts could be used to alleviate suffering and fight injustice. How dare we retreat and create?

Maybe you're struggling with the same questions. Yet it's vital to persevere in this work, and this book is an inquiry into why and how. I believe we *must* keep creating art—not by ignoring a world in distress but for the sake of loving it. How might those of us investing time, talent, and treasure to try to make beautiful things persevere when voices in our heads tell us it's a waste of time? How can we keep making through pushbacks like risk, rejection, criticism, obscurity, burnout, jealousy, perfectionism, and even success? How might we develop strength through practices that help us stay the course of a life dedicated to creativity?

I wrote this book as a guide for creative people who are concerned about justice—those who are on the journey of a "long obedience in the same direction," as Friedrich Nietzsche put it. Nietzsche would refute the claim that this is a divine mandate, but most creative artists sense a calling to create, no matter how we define the source of that call. Often, this includes a desire that our creativity is yoked to justice. Many of us want our labors to *matter* in the world—to create healing, repair, and goodness. We want our making to be just.

You might only be starting to discern that this work of making art is your narrow road. Perhaps you are already ascending the hill of a career in the art. Or maybe you've been trudging along for some time and feel you might already be

heading downhill. (I'm squarely in the latter category.) In any case, I hope this book will encourage all of us to stay the course. I've gathered wisdom from a circle of other creatives to cheer us along the way, and I include stories and lessons from my three decades of working as a writer.

But first, in the hopes that one day you'll find me and tell me your origin story as a maker, let me begin by sharing mine.

## Writing Books for Young People

I've always loved language. As I learned English and Bangla, my mother tongue, I liked playing with words, paying attention to them, and—as the youngest of three children—wielding them as a mode of power. Slowly, by reading voraciously, I began to see the potential that stories have to bring order out of chaos and create beauty in a frightening world. I also saw the way that some stories—propaganda, or what novelist Chimamanda Adichie calls a "single story" in a famous TED Talk—can fuel chaos and ignite hatred.

How I thirsted for order and beauty as a child! I credit our father for that. Baba would point to a butterfly resting on a flower and muse about a Designer who created symmetry and beauty. He'd recite poems in Bangla and English from memory and share his enjoyment over a particular noun, verb, image, metaphor, or simile. He saw all of nature, art, and the sciences as proof of a great unseen Maker's mind. Thanks to Baba, a deep longing for beauty and order was growing in my

soul, even as my awareness of humanity's entrapment in ugly chaos was increasing.

My sisters and I realized early that our parents had sacrificed substantially to leave their childhood villages in Bengal, immigrate to the United States, and raise us here. We knew we had three career options: become an engineer like my father, a doctor like many other Bengali immigrants, or . . . well, an engineer like my father and other Bengali immigrants who weren't doctors. My sisters dutifully found their way to math and the sciences.

The problem was that I wasn't drawn to those subjects. I earned decent grades but always had a penchant for poetry, stories, and scribbling in my diary. I was addicted to "fairy stories," as my mother called fiction. She'd snatch away my library book and replace it with a math textbook, so my affinity for stories quickly went underground.

All three of us (Sonali, Rupali, and I) got into excellent colleges that my parents could brag about at Bengali parties. Surely after graduating, we'd land lucrative jobs that would allow our family to claim the American dream, live in luxury, and care for Ma and Baba in their old age.

Unfortunately, the work that interested me wasn't lucrative. Bit by bit, I was drawn into the field of international development. Before long, I had declared a political science major as an undergrad and then enrolled in a public policy graduate school. I wrote a simple goal in my journal: before I died, I would eradicate world hunger, especially for children.

Animated by both a fierce longing to alleviate human suffering and the intense idealism of youth, I decided to pursue a path of humanitarian service.

How, then, did I end up dedicating the bulk of my adult life to writing stories for young people instead of making sure they were fed? I credit the "fairy stories" for that.

I knew beyond a shadow of a doubt that fiction had fueled a desire in my heart for the compassionate life. Take one of my favorite rereads, for example—*A Little Princess* by Frances Hodgson Burnett. The book stars Sara Crewe, an orphan who moved from riches to rags and back again. When Sara was in the darkest moment of her hero's journey, hungry, cold, and wet with nothing much to give, Ms. Burnett illuminated for nine-year-old me the human impulse to be a generous giver.

Instead of fixing Sara's problems with food, warmth, and dry clothes, the author chose a different route. She did this in one masterful scene in which Sara is walking along a street, cold and hungry, when she happens on a fourpenny coin shining in the gutter. Heading toward a bakery to buy some fresh hot buns, she passes a girl who is begging and asks if she is hungry.

"Ain't I jist?" the other girl responds in a hoarse voice. "Jist ain't I?"

*Just to look at her made Sara more hungry and faint. But those queer little thoughts were at work in her brain, and she was talking to herself, though she was sick at heart.*

*"If I'm a princess," she was saying, "if I'm a*
*princess—when they were poor and driven from their*
*thrones—they always shared—with the populace—if*
*they met one poorer and hungrier than themselves.*
*They always shared. Buns are a penny each. If it had*
*been sixpence I could have eaten six. It won't be enough*
*for either of us. But it will be better than nothing."*
*"Wait a minute," she said to the beggar child.*

Sara enters the bakery and buys six buns. Then in a slow, arduous act of compassion, she gives five of six hot buns, one by one, to the girl, even though she is so hungry herself.

That scene remained with me for years after I read it. I didn't grow up in a family that talked much about feeding those who were hungry, so why did I care so much about alleviating the suffering of others by the time I was a college student? That desire was cultivated by reading and rereading Ms. Burnett's story and so many others like it.

Stories showed me that humanity, strength, and dignity could be found in giving, not simply in receiving. I could have heard a hundred sermons instructing me to be generous, but none would have made me *want* generosity the way that story did. As I reflected on how fiction had so deeply shaped my soul, I could see that choosing a career of writing stories for children wasn't *setting aside* my passion for justice but pursuing it. It was my path in life; I sensed that somewhere deep inside my soul.

And so I wrote. For myself at first and then for others. My first novel, *The Sunita Experiment*, was published in 1993. But the real miracle came in 2006 (and I'll tell you more about that in chapter 4), when I claimed writing for young people as my vocation. Working as a full-time artist seemed like a career for men of European heritage, not someone like me. It still does at times. Over the past decades, though, I've learned to accept writing fiction as the *primary* way I'm intended to serve—as Frederick Buechner put it, "The place God calls [me] to is the place where [my] deep gladness and the world's deep hunger meet." Somehow, despite resistance from within and without, I've managed to keep making for more than three decades.

## Creative Perseverance in the Margins of Power

"I have come to believe that unless we are making something, we cannot know the depth of God's being and God's grace permeating our lives and God's creation," painter Makoto Fujimura writes in *Culture Care: Reconnecting with Beauty for Our Common Life* and *Art and Faith: A Theology of Making*. Other Christians write thoughtfully about making beauty as a core part of Christianity, including Stephen Roach in his slim, deep book *Naming the Animals: An Invitation to Creativity* and Andy Crouch in *Culture Making: Recovering Our Creative Calling*. Many helpful books about the creative life

aren't based particularly in Christianity: *Big Magic* by Eliza-beth Gilbert, *The Creative Act* by Rick Rubin, and the classic *The Artist's Way* by Julia Cameron. More are sure to be released in the coming years.

What then—apart from a dogged determination to write until my last cogent breath—qualifies me to add to the con-versation? Well, let's not invite the self-minimizing voices in my head to commandeer the answer too quickly. I *do* have a track record of just . . . making. Somehow I've persevered in this vocation and tried to stay faithful to it.

Anything else I can offer stems from my identities as a daughter of immigrants. My ancestors are women who made beautiful things but didn't dare to dream of art as a career. I was a third girl born to a sonless family in a culture that prized boys over girls. I grew up with raised-in-the-Bengali-village parents: a brown, shy, well-behaved girl, scared to draw atten-tion from American teachers and neighbors. I know how it feels to be unseen by others. I also revel in and claim the *power to see* that only invisibility like this provides.

In the Christian tradition, generativity takes place in the womb of a woman—first within Eve, designated and named as the Source of Life, and then inside Mary, the mother of Jesus. Creating order from chaos and adding beauty to the lives of others seem to me like reflections of a maternal, marginalized God. I've seen and touched this kind of astounding against-the-odds creative femininity in my great-grandmother's tra-ditional and painstaking *kantha* embroidery. I've smelled and

tasted that creativity in my mother's savory lamb curry, and I've heard it in my aunt's voice crooning a Tagore song wistfully and warmly, perhaps only as a mother could.

In her essay "Why Art Matters, Even in Poverty," Alison Stine writes about the magnificent creativity of Appalachian mothers raising children. Without glorifying poverty, Stine connects imagination and a lack of resources: "Why do I bother making things? One of my jobs as a poor mother is to make things, to stretch the laundry detergent with water, to fit the screws back in the car door with wire. What is living in poverty if not constantly being creative? Continually making it work? Making the unbearable, bearable. Making the money last. Making the unlivable not just livable, but survivable. So I cover up scuffs in shoes with marker. I use baking soda to wash my face. Every leftover portion from dinner, I carefully wrap and freeze."

Women who lack power and privilege have made beauty and created order during chaos, deprivation, and suffering. They have lived the creative life in the nooks and crannies of cultures across the planet. If art were war, they'd be the mighty fighters on the front line. Given the enemies they conquer to create art, they can be our greatest teachers in persevering in this vocation.

Perhaps you, too, accept that making beautiful things is a primary way of loving your neighbor when it comes to the investment of time, talent, and treasure. If so, I hope this book encourages you in that vocation, especially if you're on the

margins of power in some way. Even if you're not anywhere near the edges, I welcome you to join the work of just making. For both the former and the latter groups, here is an invitation to learn from the lowly—the brave and indomitable artists I will use as examples to clarify our call to persevere.

Part 1 explores the potential positive choreography between making art and doing justice. It can be a beautiful dance that involves four participants: first, the maker of art; second, the receiver of art; third, the wider community; and fourth, the art itself. Part 2 explores some of the forces that create discordance, and in part 3, we'll cover ten practices to keep dancing despite those forces: two to grapple with exterior opposition from the market, one to battle despair, five ancient practices to combat interior pushback from disordered values and habits that dwell within our souls, and two last practices if and when the vocation of making does clash with doing justice.

But before rushing ahead into reconciling the conflict between art and justice, let's start with harmony.

## The Way Things Ought to Be

I love the Hebrew word *shalom,* which has been translated as *peace, wholeness, and flourishing.* Words in several other languages sound akin to it in my ear, even though linguists can't prove connections. Take *salus* in Latin, *salaam* in Arabic, *salud* in Spanish, and *samsara* in Sanskrit, for example, all mean

something close to *good health*, *salvation*, or *wholeness*. For the purposes of this book, we'll consider the just life as the shalom described by the philosopher Cornelius Plantinga: "Universal flourishing, wholeness, and delight—a rich state of affairs in which natural needs are satisfied and natural gifts fruitfully employed . . . Shalom, in other words, is the way things ought to be."

In the Bible, the Jewish prophet Micah describes the good life: "He has shown you, O mortal, what is good. And what does the LORD require of you? To act justly and to love mercy and to walk humbly with your God" (Micah 6:8). I believe all human beings reflect the image of God, broken, marred, or tarnished though that image might be. I also see that justice in pursuit of shalom may be meted by deeply religious individuals in many faith traditions, as well as by nonreligious individuals. That's why, even though at times I draw from Christian writing and practices, I wrote this guide for artists or creatives of any background or belief system.

There you are, in studios and workshops and libraries and studies and concert halls and sewing rooms, seeking to generate goodness for yourself and others. There you are, trying to be compassionate and gracious in your making. I hope this guide can encourage your efforts to act justly, love mercy, and walk in humility through our shared vocation of making.

# PART I

CREATIVITY AND THE JUST LIFE

# 1

## JUSTICE FOR THE MAKER

MOST OF THE artwork in our living room was made using a simple tool that archaeologists say is more than sixty thousand years old: a needle. My female ancestors stitched their longings, secrets, histories, and laments using this tool, and now I am surrounded by resplendent, colorful artwork created by their hands. On winter mornings, as I sit by the fire with my coffee, I find warmth under a handmade quilt and finger the comforting and intricate textile pattern made by faraway, unknown hands in Bangladesh, the place where my parents were born. My eyes travel to the wall and take in a glorious piece of framed *nakshi kantha*, the traditional embroidery art of Bengal, where small stitches of jewel-colored thread invite me into a palace garden where peacocks play.

In the front hall are two other framed embroidered artworks: one drawing the viewer into a market scene in Paris and the other offering a gold-veined vase of summer flowers, both painstakingly and lovingly sewn by my sister. My husband and I splurged on framing these three works of art with museum-quality glass so that we could preserve and enjoy the details of the tiny stitches. Needlework isn't gaveled at enormous prices in a Sotheby's auction; a quick check shows that

the top price for a quilt is less than $20,000. But if you're ever in our home, my guess is that you'll take as much delight in these priceless works of art as we do.

In the opening chapters of the Bible, we're told that one of the first acts of divine restorative compassion after the fall of humanity was sewing. That's right: God sewed. "The Lord God made garments of skin for Adam and his wife and clothed them" is how the writer puts it (Genesis 3:2). God cushioned the fall of these beloved creatures by making clothes for them. So it didn't surprise me to learn that the word *quilt* in English is linked to the Latin word *culcita*, which means "bolster" or "cushion." Isn't that the kind of work women have done for families and communities for generations?

Needle in hand, women have been creating astounding works of beauty for a long time—art that has been categorized as *handicraft* or *hobby* or *folk art*. Although such art has been devalued in the markets of the art world, it offers revelatory examples of just making. As we begin exploring how creating art can result in a life of shalom, or a better, more just life for the maker of the art, for the receiver of the art, and for the community, let's start, then, with quilting and sewing.

In almost every culture and period of history, women have upcycled discarded pieces of fabric and stitched them together to create designs of beauty and order. These products are magnificent, colorful, and delightful to the eye but also provide warmth and tell stories of individuals and communities. The art of quilting has gathered women across the planet

in communal events, such as the North American quilting bee and the tradition of quilting shared by women who were enslaved, which we'll explore in more detail in just a bit. In Japan, *sashiko* ("little stabs") stitching, traditionally used to mend and reinforce fabrics, is based on *wabi-sabi*, an art technique that incorporates imperfection. Japanese quilters purposefully include uneven stitches or irregular patterns in their work.

Not many genres of art manifest this powerful combination of divine activity: salvaging, bolstering, gathering, beautifying, ordering, and transforming imperfection into beauty. If you're curious to see some of the world's most beautiful quilts with your own eyes, visit the International Quilt Museum at the University of Nebraska in Lincoln (take me along; it's on my bucket list). Or sign up for their Quilt of the Month newsletter. You may also let your eyes feast on Bisa Butler's life-sized quilted portraits or the storytelling quilts crafted by my friend Liberty Worth, who shares her vision for just making at the end of this chapter.

While it might not be obvious to the viewer, a quilter is very much responding to the call to "love your neighbor as yourself." By creating a quilt that keeps someone warm, a quilter is serving others. By also providing delight for the senses when it comes to sight and touch, these makers transform something designed for utility into a work of art.

But this call to love one's neighbor as oneself invites us to consider how art promotes justice in our *own* lives as

artists. We love our neighbors only as well as we love ourselves, and Saint Thomas Aquinas posited that we cannot love God before first loving ourselves. Making justly is work not only for others but also for ourselves. Before we turn outward, we turn inward.

We'll be able to see this idea of self-love for the artist more clearly as we continue to consider the work of quilters. Quilt making provides space to understand and express emotions, offers a venue for voice, creates a way for the mind to escape the stress of human existence through flow, and provides more economic power (sometimes). Let's look at each of these gifts that come to the artist.

## Expression of Emotion

At times, we don't know what we're feeling until we make art. The body itself expresses emotion through the creative process, the art speaks as well, and then the mind begins to grasp what the heart is feeling. Art therapists use creativity to help people who have experienced sorrow, trauma, and grief move forward and receive healing. As we make, subterranean emotions are released and lose their toxic power to drive us. There's a sense of emotional release, even if we're not aware of the emotions that spur us forward through the process.

This happens for women around the globe as they quilt. In *Nakshi Kanthar Math*, the poet Jasimuddin imagines a woman's interior life as she embroiders her *kantha*: "Spreading

the embroidered quilt / She works the livelong night, / As if the quilt her poet were / Of her bereaved plight. / Many a joy and many a sorrow / Is written on its breast; / The story of Rupa's life is there, / Line by line expressed."

Art therapist Jessica Gardner suggests that quilting is deeply healing. Gardner studied the effects of quilting as a form of group art therapy for older women and found that it increased their sense of well-being. Quilting, she claims, facilitates the aspects of art therapy Lisa D. Hinz outlines in her book *Expressive Therapies Continuum*. Quilting involves the senses (primarily sight and touch); the movement of the body (kinesthetic); affective or emotional expression; and perceptual (involving strategic planning), cognitive (engaging the brain), and symbolic (wanting to communicate meaning) awareness.

Quilting, thanks to its communal nature, might be even better at releasing emotion than other art forms because women share thoughts and feelings with one another as they sew. In an article titled "Kinship and Quilting: An Examination of an African-American Tradition," Floris Barnett Cash writes, "Quiltings were both labor and leisure activity. [Women who were enslaved] created their own culture or way of life to liberate themselves from an oppressive environment. Quilting, accompanied by eating, storytelling, games, and singing, offered . . . unique opportunities to socialize without supervision."

To see how healing your primary genre of creativity might be, put it to the test by seeing how deeply it draws from

the domains of art therapy: sensory involvement; kinesthetics; emotional expression; and perceptual, cognitive, and symbolic capacity. When you consider various art forms according to this heuristic, you'll likely find that dancing, painting, sculpting, cooking, and gardening each join quilting in covering the continuum.

Writing, sadly—for me and other authors—doesn't involve the senses other than through the imagination and demands little or no movement of the body other than fingers flying across the keyboard. Perhaps those drawbacks make its healing effects less potent. Still, I can attest that writing, especially poetry, has value in expressing sorrow, joy, disappointment, or desire. To gain access to my own emotions, I take a pen to my journal and write a poem that nobody else will see. As I read my composition to myself, I perceive deep emotions that have been driving me from the inside. Creating calls me to pay attention to what I'm feeling, even if it's pain I don't want to face.

These days, some of my pain comes from growing older in a society that devalues age. Gardner also argues that quilting can help women heal from the loss of aging and the feeling of becoming invisible and discarded. Through quilting, she claims, quilters can make meaning by making old fabric purposeful again. "The act of cloth being re-purposed into a quilt . . . symbolizes purposeful and renewing qualities to something that has aged and been discarded," she writes. "This meaning making process could allow older women to experience

feelings of being liberated from the imposed stigma towards being an aging and older woman. Older women may connect with this concept metaphorically, allowing for new meaning towards personal aging and purpose to emerge within society."

Therapy is a gift, but it is an expensive one, and it's only accessible to people of privilege on the planet. The sharing of emotions and narratives as women make art together is a way that even the least powerful people can participate in therapeutic conversations and environments.

## Venue for Voice

Most people have a difficult time distinguishing my sisters' voices from mine because the three of us sound so alike. But our father knew which of us was calling after hearing a mere syllable of greeting on the phone. The human voice, like a fingerprint, is particular to each human being, and art provides a venue to express this.

In fiction, as with other forms of art, voice is not something that can be taught. The writer Meg Rosoff describes it this way: "Your writing voice is the deepest possible reflection of who you are. The job of your voice is not to seduce or flatter or make well-shaped sentences. In your voice, your readers should be able to hear the contents of your mind, your heart, your soul."

Every art form provides space to express this unique, creative voice. Musicians interpret songs differently, and painters paint the same scenery in divergent ways. Quilts, while often

made communally, can reflect the vision and talents of individ-
ual artists. An individual woman sometimes pieces a quilt on
her own, choosing and cutting and placing fabrics in relation
to each other; only when she is ready to stitch the quilt top to
wadding and to backing do other women help. One woman
initiates and designs an offering of art for the rest.

Zanne Aroa writes about what quilt making offers to Black
women. These words could apply to many women makers on
the margins:

> *Quilting allows . . . quilters to explore and affirm*
> *their personal identities. Through their use of color,*
> *symbolism, and storytelling, quilters express their*
> *values, experiences, and aspirations. Quilts become a*
> *medium through which they convey their individuality*
> *and assert their place in the world. Each quilt is a*
> *unique reflection of the quilter's personal journey.*
> *From the choice of fabric to the intricate patterns,*
> *every stitch tells a story. Some quilters incorporate*
> *symbols of strength and resilience, while others use*
> *quilting as a way to honor their ancestors and celebrate*
> *their cultural heritage. The process of creating a quilt*
> *becomes a form of self-expression, allowing quilters to*
> *connect with their roots and find a sense of belonging.*

Throughout Tanzania and Kenya, women use *kangas*, or light-
weight cotton, to create quilts defined by bright patterns,

vibrant designs, and Swahili phrases or proverbs. Kanga quilts might generically include animals, flowers, traditional symbols, and scenes from daily life within the constraints of the art form, but each finished product is different as it reflects the specific identities, stories, and messages of a particular maker.

## Forgetfulness in Flow

Growing up in Hungary after World War II, Mihaly Csikszentmihalyi saw people around him struggling to rebuild their lives after the war. He watched as some lost the will to even try and became preoccupied by a single question: what makes life worth living?

Csikszentmihalyi moved from Hungary to the United States to study psychology and answer this question. He wondered at first if wealth fit into the equation of people's notions of a life well lived. But the data showed money wasn't the answer to what made people feel life was worth living; beyond a basic threshold, increases in income didn't affect flourishing. So where in everyday life, in our normal experience, did humans feel happy?

Csikszentmihalyi discovered that we are happiest when in a condition he called *flow*. He defined it as "a state in which people are so involved in an activity that nothing else seems to matter; the experience is so enjoyable that people will continue to do it even at great cost, for the sheer sake of doing it." This state takes our eyes away from our own and the world's

distress. It gives the mind relief. It's accompanied by physio-logical changes too. A 2010 Swedish study of classical pianists, for example, found that musicians who entered a flow state exhibited deepened breathing and slowed heart rates. Even facial muscles that enable a smile were activated.

I've experienced this flow state while writing. The process, which can sometimes be onerous and dull, becomes uplifting, freeing, and exhilarating. In flow, I escape the relentless pas-sage of historical time as the act of writing somehow takes me out of it.

Imagining women in difficult, desperate circumstances receiving this gift as they stitch brings me joy. Aroa, for exam-ple, describes the meditative act of quilting. "When you sit down to quilt, you enter a state of flow, where your mind becomes fully absorbed in the process," she writes. "As you focus on each stitch, your worries and anxieties melt away, replaced by a sense of calm and tranquility. The repetitive nature of quilting allows you to enter a meditative state, where you can let go of stress and connect with your inner self."

I like to reflect on how quilts I own most likely have also been a gift for the makers. When I lived in South Asia for several years, I saw firsthand the mental and physical strug-gles of women. Many told me their stories of suffering and sorrow—stories that inspired me to write some of my novels. My voice, however, was the conduit for those books; I could channel their voices only indirectly. The *kantha* quilt in my

living room, on the other hand, was voiced directly by some of those women. As I fold it and drape it over the back of my sofa, I find a measure of solace in picturing the women who made it. I wonder what respite from suffering the creation of this piece of art might have offered them.

## Economic Power

While there is beauty in creating for art's sake alone, the gift of paid work elevates an artist's quality of life as well as the spirit. Adding income to your household underlines the dignity of making art. In my travels, I enjoy buying products made by women artisans who are trying to provide for their families. When I put on a paisley shawl woven in the Himalayan region of Nepal, silver earrings crafted in rural Mexico, or a cotton skirt embroidered in the high Andes of Peru, I feel connected to the women who made them. As a full-time artist myself, I share what I imagine to be their satisfaction in imagining me. We connect in their joy of creating a product that another person values enough to buy.

During the mid-nineteenth century, Elizabeth Hobbs Keckley was born enslaved on a plantation in Virginia. As a teenager, she was sold and moved to St. Louis, Missouri. Soon, by making and selling magnificent quilts, she was providing for herself, seventeen other people, and even the man who called himself her master for over two years. She saved enough money

to free herself and her son from slavery, moved to Washington, DC, and became a professional seamstress and quilter for Mary Todd Lincoln. What a journey to dignity and flourishing!

Keckley and others like her are the proverbial exception that proves the rule, however. Mostly, history shows that women who quilt were co-opted or exploited by more powerful people. Take Harriet Powers. She was born in slavery in 1837 and exhibited her famous Bible Quilt at the 1886 Athens Cotton Fair. Jennie Smith, a wealthy, established artist, fell in love with Powers's original design and offered to buy the quilt. At first, Powers refused to sell. She changed her mind four years later when facing economic duress. It's difficult to hear that Smith negotiated the price of this stunning quilt from ten dollars down to five dollars. That's why when we talk about just making, we can't overlook the way that economic shalom for the makers themselves happens—or doesn't. When we purchase art like jewelry or a quilt crafted by hands with less privilege than our own, justice compels us to ask this question: who profits?

We'll explore this question as we move to the next participant in the dance of creating just art: the person who consumes or receives it.

## Just Quilting

*"I ask myself all the time, 'How do I stand for*
*justice without becoming another "preachy" voice*
*in the cacophony of noise?' Where I have landed in*

*my answer to my own question is to do my best to stay open-minded and open-hearted to the stories of others. Listening to the stories that you tell me about your experiences, people, history, hopes, and dreams excavates space in my heart to empathize with your world and your life.*

*Sharing stories, listening to others' stories, and partnering with people to share their stories has become the path to justice in my work. I believe textiles hold memory and stories. My work is an exploration into those narratives and into the act of creating and mending something new and whole from disparate pieces."*

*—Liberty Worth, textile artist*

# 2

## JUSTICE FOR THE RECEIVER

MY MOTHER CRAFTED tasty and frugal meals in her kitchen, whether that kitchen was in Kolkata, New Delhi, Ghana, Cameroon, New York, Mexico City, London, or in the San Francisco Bay Area, where we finally settled when I was in seventh grade. On weekend afternoons, after Baba took us to the tennis court or the library, we'd return home to the savory smells of fish, Bengali village-style lentils, and *luchis*: the puffy, round breads that Ma mixed, rolled, and fried on a flat skillet. As I'd take my shower, my mouth would water in anticipation of the meal. We never ate fast food, and it turns out that Ma's cooking, like most food made by women in villages around the planet, was nutritious and healthy along with being tasty.

We turn now to the question of what just making looks like for the *receiver* of the art. To do that, we'll look at a realm of art that directly and practically benefits the receiver: cooking (or the culinary arts, as it's called when more powerful people move into the kitchen). Around the world and through history, homemaking is an unseen and overlooked work of art, and much of that creativity takes place around a cooking fire. Cooking pays even less than quilt making, but it

brings great flourishing to those on the receiving end of it—
especially to children and young people with growing bodies
and hefty nutritional needs.

Let me preface this section for readers who, like me, are
not skilled in this form of art. Take heart—we might not be
the best concocters of food, but we can enjoy products made
by those who are! In the same way that we commit ourselves
to just *making*—supporting ourselves and other artists in
the expression of emotion and voice and flow and economic
dignity—we must also commit ourselves to just *receiving*.
There's work to be done on the receiving end of art if we
want it to result in justice. As recipients of beauty—including
beautiful food—we ask the question of who profits from our
consumption of other artists' work, especially if the maker is
benefiting only a bit, if at all.

As a graduate student, I spent a year in Kolkata doing
research on literacy and economic development. Sometimes
I would visit the homes of children who, instead of attend-
ing government-sponsored reading programs, spent all day
straightening bent nails to sell to businesses. A child would
lead me by the hand into her home, pulling aside the faded
sari that served as a screen door. In the single room inside
without furniture, a chair would miraculously appear, usually
borrowed from somewhere in the community. Soon a smiling
mother would hand me a cup of delicious tea and a plate of
store-bought biscuits. The inequity in this exchange—these
women spending money to feed me—made me shudder, but

I received it. How could I not? My mouth still remembers that homemade, cardamom-spiced tea and the warm welcome given to me by those women. Somehow, along with taste and nutrition, that milky tea fed me a mix of tenderness, strength, and courage.

I received that same tenderness, strengthening, and encouragement during my first visit to my husband's childhood home in Southern California. My mother-in-law—blond, blue-eyed, dressed in high heels with a lacy apron over her wool suit—had set a table that rivaled the one prepared for Beauty by the kitchen in Beast's castle. Candlelight flickered across china and crystal, and we feasted on salmon, rice, and asparagus cooked to perfection. Beyond the feast, though, I took in Mom Perkins's welcome—her smile so similar to the ones on brown faces in those Kolkata homes—and the delight she took as we received her creativity.

My mother-in-law died last year, and I take comfort in believing she's being fed by a Shepherd who has prepared a table for her as described in Psalm 23 of the Bible. I can picture his welcoming smile because it's reminiscent of hers and of the women in Kolkata. He's the same guy who cooked breakfast for his friends—women's work, typically—after they thought he was dead: "When they landed, they saw a fire of burning coals there with fish on it, and some bread. Jesus said to them, 'Bring some of the fish you have just caught.' So Simon Peter climbed back into the boat and dragged the net ashore. It was full of large fish, 153, but even with so many the

net was not torn. Jesus said to them, 'Come and have breakfast'" (John 21:9–12).

Cooking, like quilting, reflects a maternal divine image: along with order and beauty, it offers delight for multiple senses and nourishment for the body. Taking the products of soil, water, and sunshine—fruit, vegetables, roots, spices, crops—a cook mixes them, transforming them with fire to give life. Here's what justice looks like for a receiver of art: tenderness for the body, strengthening of the soul, and encouragement for the heart.

## Tenderness for the Body

Consuming art is good for the body. And that's not just some nice, abstract idea. Koenraad Cuypers, a researcher at the Norwegian University of Science and Technology, used data from an extensive study that asked fifty thousand Norwegians ages thirteen and up how often they attended galleries and museums, viewed films, and consumed other art. Cuypers discovered that receiving art correlated with good health, satisfaction with life, and lower rates of anxiety and depression in both men and women.

I create art with words, but often language doesn't do the trick when it comes to affecting us at a physiological level. Visual art, dance, and music circumvent words to offer consolation to the body in a more potent way—as does food. In films like *Babette's Feast*, *Chocolat*, and *Like Water for Chocolate*, the power to heal others is linked to cooking or baking.

When I'm sick, I want a bowl of homemade soup made by someone who loves me; don't you?

Consuming a meal, like taking in other forms of art, increases the level of "happy hormones" in our bodies. When we look at a stimulating painting, for example, our levels of the hormone serotonin rise, stabilizing our mood and feelings. Serotonin has an impact on the functioning of the entire body and enables brain cells to interact with other cells of the nervous system, resulting in a feeling of satisfaction and happiness. "We know that when a person views something that they find beautiful, for example, a face or an abstract art painting, their brain's pleasure centers light up and its visual sensory center is engaged more intensely," says Ahmad Beyh, a neuroscientist at Rutgers University. Beyh adds that "this is accompanied by a release of dopamine, which is also known as the feel-good neurotransmitter."

When it comes to food as the product received, the hormonal reaction is even more intense. The pleasure of eating releases dopamine and endorphins; savoring a meal in good company boosts oxytocin levels; and many common ingredients—including eggs, milk, nuts and seeds, spinach, fermented food, fruits, and vegetables—lead our body to make serotonin. Food, cooked and served in a safe place by loving hands, activates the same reward and pleasure centers targeted by some depression treatments.

Cooking for others is a divine art because it offers tenderness to frail and needy bodies. A mother's body is designed to

nourish another's body; maybe that's why one of the hardest trials she can face is the struggle to feed her children. It's hard enough with resources, but without them, it's agony. Rebecca McLoughlin, in an essay titled "How Breastfeeding Changed My View of God," writes about the creativity it takes to feed a helpless human being:

> *At first, nursing was agony. Neither I nor my daughter knew what we were doing. Both of us were frustrated and distressed. I'll never forget one nurse's comment, delivered kindly, but like a knife to my heart: "My observation about this baby is that she is very hungry and very tired." I felt desperate. Gradually, we got the hang of it. But then came the real test. The frequency with which my baby needed to feed was exhausting. Some nights, I would hear her cry, and long from the depths of my soul not to go to her. I was more drained than I ever imagined. I felt like a climber scaling Everest, wanting nothing more than to lie down in the snow to sleep—too tired to heed the consequences. But I knew my baby needed me. So, I got up, crawled through my exhaustion, and went to her.*

The arduous work of feeding a child can serve as a metaphor for many kinds of art making. Just making means facilitating the flourishing of another human being by surrendering your body

to a life-giving task. But for the receiver of art, the result—of reading a poem or standing in front of a painting or closing our eyes at a concert—can be like a nourishing meal. It can be the sating of a hunger that had made us wail in the night.

## Strength for the Soul

"Earth's crammed with heaven, / and every common bush afire with God, / But only he who sees, takes off his shoes," wrote Elizabeth Barrett Browning in her epic novel in blank verse, *Aurora Leigh*, published in 1856. There's a burgeoning science suggesting that feeling awe is good for the soul. In *Awe: The New Science of Everyday Wonder and How It Can Transform Your Life*, psychologist Dacher Keltner demonstrates how experiences of awe correlate with feelings of well-being and calmer nervous systems. When we learn to look around us with awe—at paintings, quilts, food, or, as Browning writes, even at a bush—our souls and minds are strengthened.

Art historian Elissa Yukiko Weichbrodt writes that art helps us develop the practice of a loving gaze, both given and received. In order to love, we must first *look* with a curious, generous gaze. She gives examples of God's looking in the Bible to establish a "model of redemptive looking," which "is utterly different from the objectifying gaze that is so common in our contemporary culture. Too often we look to consume, to surveil, to control, and to condemn. But as the beloved of God, we are called to mimic his gaze." As we take in a piece of

art with this kind of slow looking, we receive a deep, personalized pleasure. We begin to be seen by the art.

Practicing this loving gaze with art can also help us offer it to human beings—seeing each person as a complex work of creativity and yet individually loved. "We all just want to be called by the name our mom uses when she's not pissed off at us," writes Father Gregory Boyle in *Tattoos on the Heart*. "Dinner's ready!" comes the call from the artist in the kitchen. If she's anything like God, she'll greet us with a loving gaze and use our nickname to welcome us as we race to the table.

## Encouragement for the Heart

Art created by others builds our courage to live the just life. We read a hero's journey in fiction, and it fortifies us to face our own all-is-lost moments. A song like Sara Bareilles's "Brave" can get us out of bed to face a tough day. Visual art can inspire us to innovate and attempt big, new things. And there's nothing like a delicious home-cooked meal accompanied by loving conversation around the table to give us courage to face a dark night of the soul. On the last night they would be together before his death, guess what Jesus crafted with care? A Shabbat dinner made by loving hands.

It might be this connection to someone else's hands that makes art a vehicle of encouragement. My sister and her family lost their home to a devastating fire in Colorado. Her heart was broken, her faith in the goodness of a loving God shaken and

upended. That house was a place where so many—including me—received the grace of hospitality and laughter she had offered so freely as well as counsel and shepherding from her husband, a Presbyterian pastor. It was the home where my nephews were raised with stability and security, full of memories of creative and athletic childhoods, all gone now, charred to embers and ashes by a wind-driven fire of 1,700-degree heat that incinerated everything in its wake.

A few weeks after the fire, three volunteers from Samaritan's Purse, clothed in hazmat suits, met my sister at the site to search for anything that could be salvaged. Hours passed. They found nothing. My sister, shivering in the Colorado ice and snow, was about to encourage them to give up when one of the middle-aged women hunting in the rubble leapt to her feet. She was clutching something circular that glinted in the sunlight.

"Gold!" she shouted. "I found gold!"

The woman beside her also jumped up, hand aloft, voice resounding with glee. "I found gold too!"

And yes, the third volunteer rose to her feet and joined the chorus also: "I did too!"

They were holding golden bracelets and a necklace that had belonged to our great-grandmother, who died in a village in what is now the country of Bangladesh. Forged far away and long ago by some unknown goldsmith, etched with delicate designs, these necklace and bangles that Ma had worn on her wedding day were made of Indian gold so pure they hadn't

melted. The only other pieces of art that survived the fire were a few ceramic sculptures my nephews had made during art classes in elementary school. These, too, were irreplaceable treasures.

When my sister described what had been salvaged from the ashes, her voice had a hint of hope and faith I hadn't heard in weeks. These two bracelets, one necklace, and half a dozen ceramic pieces were works of art from a lost past that she could now hold and touch and see. As I write, my sister and family are poised to move back into a new house, rebuilt from the ground up two and a half years after their old home was destroyed. The ceramic art made by my nephews' small hands and the golden bracelets and necklace are going with them, reminders of a beautiful heritage that can be neither lost nor destroyed.

## Just Stories

*"I always weave hope into my stories, planting seeds of compassion and empathy along the way because I take the long view. If the world is going to change for the better, young people have to be engaged, uplifted, encouraged, and inspired to create that better, more just world.*

*Story is a powerful tool for achieving that end. My readers tell me so: 'Dear Ms. Grimes, I'm very happy I read this book [*Bronx Masquerade*]. You*

*made me realize that even though we look different on the outside, we are pretty much the same on the inside. Everybody should read this book to help them change the way they think about other people they make fun of. I know it changed the way I think of people."'*

—*Nikki Grimes, author of more than one hundred award-winning books for children*

# 3

## JUSTICE FOR THE COMMUNITY

HOW MIGHT THE making of art do justice in and for a suffering world? In some ways, that's the central inquiry of this book. In the life of a creative, the two goals might seem to conflict. Given the time and solitude required to create, art can appear to live in opposition to activism.

We will likely never resolve the tension between doing justice and making art in a brutal and brutalizing world. But making art and doing justice have more in common than we might first think. Art is the attempt to bring some form of order out of mess, reminiscent of God's work to transform Tohu va-Vohu ("formless and void") in Genesis 1:2. Justice seeks to bring order as well, by encouraging "the habit whereby a man renders to each one his due by a constant and perpetual will," as Thomas Aquinas wrote in *Summa Theologica*.

In both making art and doing justice, however, we place constraints on both order and liberty as goals. Too much emphasis on order makes art dull and didactic, and too much emphasis on order in human institutions leads to coercion and rigidity. Too much focus on individual liberty results in art that is self-absorbed or mediocre in quality, and too much emphasis on individual liberty in justice leads to denigrating

the common good. To serve self, neighbor, and community, artists and justice makers alike must find a balance between authority and freedom.

As art critic Jed Perl writes, "For the artist it's never enough that the work is well made. The well-made work is the work that acknowledges the authority of a tradition and does nothing more. The artist must engage with the freedom that's possible within that tradition, so that making becomes an exploration of how things have been made in the past and involves some element of remaking—not replicating or reproducing but evaluating what has already been done and then making adjustments, whether large or small." Honoring the work of others as well as the rigor of the craft while expressing our own voices and creativity in freedom—that's loving neighbor and self justly.

We turn now to the last participant in the dance between justice and art: the wider community. What role can art play in bringing shalom to the wider community? How might the priorities of artists and the plans of activists overlap as both try to further goodness and justice and hope?

## Caring for Culture

*Kintsugi* (金継ぎ, "golden joinery"), also known as *kintsukuroi* (金繕い, "golden repair"), is the Japanese art of repairing broken pottery by mending breaks with lacquer mixed with powdered gold, silver, or platinum. Artist Makoto Fujimura,

one of the leading figures in the slow art movement, claims that artists living in places where culture wars divide, as in the West, have an important role to play. In an interview with *Plough*, he describes a mandate to care for culture by generating "Kintsugi-style" works of beauty. "The idea of 'culture care' is to seek to love culture as an exile in the 'Babylon' we are called to serve. Culture care is a nonviolent antidote to a culture-wars mindset where scarcity rules in fear," Fujimura writes. "In kintsugi, we are to 'mend to make new' rather than 'fix,' to make the fractures more beautiful by first beholding them, and then to use Japanese lacquer and gold to accentuate the beauty of fractures, rather than hide them . . . We are to value people and their differences, each with a unique journey of brokenness."

As a philosophy, *kintsugi* embraces rather than tries to hide the mess of pain and conflict, modeling the incorporation of rupture and repair as part of our shared communal history rather than something to cover up or disguise. But what about in places where there is no culture war at all but a situation of one-sided oppression, persecution, silencing, and injustice? Is it possible that artists might serve that society by igniting revolutions to smash the vase altogether?

To illuminate this prophetic and even revolutionary call for artists, let's delve into a more modern art form: the work of social media creatives. As in the realm of cinema, these artists weave together words, visuals, and music. Many social media artists—some might identify them as *influencers*—are

women. Some are too young or too old, too "foreign" or "too much" of something else, and are thus overlooked in the real world. Maybe that's why this art form is dismissed and devalued. Many critics and gatekeepers ignore the generative power bursting forth in reels, posts, and stories—until, that is, creatives start making money and ignite revolutions.

Both things—commerce and protest—are happening. According to a 2023 report, 77 percent of influencers actively monetizing their content are female. Currently, the most female-dominated platform among influencers is Instagram, where 78 percent of influencers monetizing their accounts are women. TikTok is 76 percent female, and YouTube is 69 percent female.

~~I cannot lie:~~ I, too, enjoy social media. As a place to promote my books, it helps me financially. But it's also a way for my words and thoughts to reach a circle of receivers who might never read my longer work. I seek to serve that circle by filling my feed with as much goodness, truth, and beauty as I can invent. I try to be a producer of art on those platforms.

As a consumer of others' creativity on social media, I delight in the humor, satire, short film, photography, design, illustration, and commentary offered on a daily basis. Of course, too much consumption of posts and reels can damage our souls. Passive consumption of social media can become a fire—one that sears, inflames, destroys, and incinerates creativity along with virtue. Practices of Sabbath, fasting, retreat, embodied community, and sacramental worship can keep us boundaried

and in some safety, as we'll see in chapter 9. But despite the dangers, these relatively new venues (*third places*, as we'll define them in chapter 8) give voice to artists who promote justice.

Beyond the headlines, ads, money, and trending topics, revolutions have been sparked on social media, fueled by the creativity of women dwelling in places where we are oppressed and our art is silenced. These prophetic artists use their platforms to form circles of solidarity, transmit truth, and confront control.

## Circle of Solidarity

In the West, many of us watched the Me Too movement unfold online. What we might not have seen is how the hashtag #MeToo spread across borders to build community among victims of sexual assault and harassment in the Middle East and North Africa, or MENA, a region of the world where women typically have less freedom and fewer rights. MENA countries include Algeria, Bahrain, Egypt, Iran, Iraq, Israel, Jordan, Kuwait, Lebanon, Libya, Morocco, Oman, Qatar, Saudi Arabia, Syria, Tunisia, the United Arab Emirates, Palestine, and Yemen. Sudan and Turkey are sometimes added to the list.

Digital activism originating in these countries shares a similar trajectory in sparking change. Typically, photographers, painters, writers, and other artists share a story of one woman's suffering in a compelling way. A hashtag is created, and the quest for justice begins to gain momentum. Soon,

such a large group of solidarity is created that single voices can't be silenced.

Writer Mireia Faro Sarrats offers some other examples of generative work taking place on social media:

> *In 2019, the Facebook page "My Stealthy Freedom" reached over one million followers. This campaign started in 2014, when an Iranian journalist posted a picture on Facebook of herself without a hijab. This led to a massive response of Iranian women doing the same, posting pictures of themselves without the chador, creating a huge community of women that spoke out against the obligation to wear this Iranian garment. In Morocco, back in 2013, #RIPAmina was a campaign against the Penal Code's Article 475, that allowed a rapist to avoid prosecution and jail if he married the victim. Thanks to mobilization and public pressure, this article was repealed in 2014.*

Sarrats describes how stories and hashtags like #LetAfghan-GirlsLearn and #FreeHerFace have helped women in Afghanistan not feel alone since the Taliban takeover. Traditional media didn't cover the devastating news that the government banned girls from returning to school indefinitely and forbade Afghani women from showing their faces in public. The situation in Afghanistan vanished behind stories about Russia and the Middle East. Social media, however, kept those otherwise

forgotten girls and women encircled and connected. #Free-HerFace even provoked a few journalists on Afghan television channels to wear masks in solidarity with women coworkers and protest the Taliban's oppression.

Some consumers of social media here in the United States fled Twitter after it came under new ownership and became X, but others stayed to follow these and other hashtags on that platform. I, too, want to remain in the circle around persecuted women and continue to receive and share their stories. "Speak up for those who cannot speak for themselves, for the rights of all who are destitute," a biblical writer advises in Proverbs 31:8–9, and artists based in MENA countries are doing just that on social media.

## Transmission of Truth

"Let me make the songs of a nation, and I care not who makes its laws." While this quote is sometimes attributed to Damon of Athens, an ancient Greek philosopher, or to Andrew Fletcher, an eighteenth-century Sottish patriot, the sentiment rings true. Art has always sought to make the invisible visible, recover the past, and explain the present. It has the power to shatter clichéd narratives that conceal the truth. The artist chronicles who we were, where we came from, and who we are becoming, for better or worse.

Russian poet Anna Akhmatova, at the height of Stalin's terror, was standing in a visitor line at a prison in what used to

be called Leningrad and is now St. Petersburg. After hearing someone call Akhmatova's name, a woman with a disfigured face drew near to the poet. "Can you describe this?" she whispered. "Yes, I can." Akhmatova answered. "And then something like a smile passed fleetingly over what had once been her face," the poet wrote in an elegy titled "Requiem."

Akhmatova became one of the many eloquent and powerful voices to validate a history that others try to reframe or sanitize. Between 1935 and 1961, she worked secretly on "Requiem," which was eventually published in 1987. The elegy contained ten poems that articulated the despair, grief, loss, and terror suffered under Stalin's tyranny. Here's a stunning example of how her poetry tried to hold on to the truth of what happened in post-World War II Russia: "Then I learned how faces fall apart / How fear looks out from under the eyelids, / How deep are the hieroglyphics / Cut by Suffering on people's cheeks."

When it comes to revealing truth that others can't or don't want to see, we're usually not talking about art made for the masses. Søren Kierkegaard wrote, "To win a crowd is not art; for that only untruth is needed, nonsense, and a little knowledge of human passions. But no witness to the truth dares to get involved with the crowd."

Sometimes, of course, there is truth telling in popular art. Take some of the musical artist Beyoncé's lyrics, for example. But in most cases, our eye is drawn to popular art because it reinforces our narrow way of seeing and remembering. Art

that transmits truth is often unheralded in the moment it is released because most of us neither want to widen our vision of the future nor change our version of the past. This is why fake news spreads so well on social media; it feeds a narrow way of seeing the present and remembering the past. Art that tells the truth opens our eyes to see communities and history in fresh ways that are uncomfortable.

So how do we find the few truth-telling storytellers and artists on social media? Beyond celebrity, profit, and virality, they are there, generating art with integrity, transparency, protection of viewers' privacy, and accountability. Organizations like the Trust Project and the Reuters Institute of Journalism at the University of Oxford help us find such sources when it comes to digital journalism, including paintings, poetry, photographs, cartoons, illustrations, posters, stories, videos, and other art forms shared on social media.

Let me offer a caveat, however, on using art primarily as a vehicle for truth. I'm often asked this question as a writer for children: "What moral or message do you hope the young reader derives from your work?" A guiding principle in my creativity is encapsulated in these words from beloved writer Katherine Paterson, author of *Bridge to Terabithia*: "The challenge for those of us who care about our faith and about a hurting world is to tell stories which will carry the words of grace and hope in their bones and sinews and not wear them like fancy dress." If a message becomes our driver in making art—to communicate our truth, to preach—we override the receiver of art.

Art is essentially a relationship of mystery—a dance with a creative product that takes place among makers, receivers, and communities. When meaning or truth is commandeered by the maker, art morphs from the prophetic into propaganda. The shift along the spectrum between the two is subtle, but the receiver and the wider community will eventually feel it. We will talk about a practice that can help us resist this disordered way of making in chapter 10.

## Confronter of Power

The nonprofit organization Freemuse's report *The State of Artistic Freedom 2023* focused on ten countries that take extreme measures to suppress creative dissent. These were China, Cuba, Egypt, Iran, Myanmar, Nigeria, Russia, Thailand, Turkey, and Ukraine.

Let's take Iran, one of today's most inhospitable places in the world for free expression in art. According to PEN America's Freedom to Write Index, which provides an annual count of jailed writers worldwide, Iran is the largest jailer of women writers globally. In 2022, Iran became second, after China, among the world's worst jailers of writers of both genders, with the Iranian government imprisoning almost three times the number of writers from the previous year.

Mahsa Amini, a Kurdish woman, was detained in Tehran on September 16, 2022, by Iran's "morality police" for not wearing her hijab properly. She died three days later in police

custody. Her birth name was Jîna, which means *life* in Kurdish. Amini's death in police custody in Iran last year led to protests, most of which were sparked by artists on social media:

1. Shervin Hajipour's song "Baraye" and his chant *azadi*, meaning *freedom*, spread like wildfire via Instagram. The musician was arrested days after posting the song, and it was removed from social media but not before it went viral. The video of schoolgirls joining hands to sing was heard and shared by millions.

2. Graphic artist Meysam Azarzad designed a poster that includes this quotation from the eleventh-century epic *Shahnameh* by Ferdowsi: "This massive army is useless. Indeed, a single fighting girl is worth hundreds of thousands of them." Her work was also shared countless times.

3. Another poster by Roshi Rouzbehani called "My Hair Is Not Your Battle Ground" featured the slogan "woman, life, freedom." Posted widely on the internet, it inspired a growing number of young Iranian women to cut their hair, which is a symbolic gesture of mourning in Iran.

4. An editorial cartoon titled "Music v the Mullahs" depicted Toomaj Salehi, a rapper who was jailed for criticizing the Iranian regime in his songs, playing chess. It, too, was seen by many.

5.  Narges Mohammadi was jailed on false charges of
    "spreading anti-state propaganda" and defamation.
    At age fifty-one, having endured torture and solitary
    confinement and more than ten years in prison,
    Mohammadi wrote *White Torture*, a book exposing
    the physical and psychological abuse in Iranian
    prisons through the stories of fourteen women.

The creative courage demonstrated by artists in Iran and
other oppressive countries is a call to keep pursuing justice
in our own art. Even female artists on the upper end of the
power spectrum must fight to carve out economic control
and creative freedom in traditionally male-controlled indus-
tries. Recently, the musician Taylor Swift rereleased six of her
albums so that the new versions, owned by her, would out-
perform the original versions sold by music manager Scooter
Braun for $300 million in 2019. As one journalist writes:

> *Greater equity was the central consideration of Swift's*
> *label change—along with greater certainty that*
> *all who contributed to making the art itself would*
> *benefit from their work. . . . That this financial*
> *nitty-gritty is what excited Swift most might seem*
> *at odds with her image as a singer-songwriter who*
> *performs on sets that look like a cottage in a fairy-tale*
> *forest. But that persona hides Swift's savvy: she's long*
> *understood that artists, even those with brands as*

*powerful as hers, are vulnerable to exploitation. After*
*building an empire writing deeply personal songs,*
*should selling her story really come so cheap?*

If women from the least to the most privileged can make art
that confronts powerful interests aligned with injustice, then
we can too.

But whether we're in a society that is relatively freer
about artistic expression, when seeking to make art that pro-
motes shalom, we will face pushback. In part 2 of this book,
we'll look at nongovernmental forces that make creatives give
up: enemies from without and within. Fasten your seatbelts,
readers, because the journey of creativity is a turbulent one.

## Just Figurative Art

*"People who know me well know that I wrestle with*
*this question: why, in this broken world, should*
*people continue creating visual art and music and*
*dance and poetry? I volunteer in the mornings,*
*teaching children and young adults how to read; isn't*
*that more important? My answer is that the world*
*needs both. The world needs radical acts of service,*
*and the world also needs art.*

*I created a painting of a group of people*
*holding candles in the twilight. It is hanging in an*
*environmental law office. The lawyer who bought*

*it said it was to remind her staff of what they are fighting for. I was recently in an art exhibit on climate change. I showed a painting titled 'Leaky Buckets' of a woman facing a long horizon of flames, the sky dark with smoke. She was holding two dripping buckets. Some people found it disturbing. A couple looked at it and said, 'We need hope! This is too dark.' So be it. Sometimes art needs to give us hope, but sometimes we need to be disturbed. A hospice patient looked at a painting of a woman floating out a window into a bright sky. She told me, 'I always thought I'd go into darkness when I died, but when I look at this, I realize I'll go into light.' Art is vital because the world needs beauty, community, truth telling, and joy."*

—Carol Aust, fine artist

# PART II

## WHY WE STOP MAKING

# 4

## A BRUTAL, EXCLUSIVE MARKET

IF CREATING BEAUTY can be one way to bring shalom to a hurting world, why is it still so hard to keep making? A broader answer is contained in the question itself. When something *matters*—when creativity or innovation moves people toward flourishing—pushback is inevitable. The default mode in this world is entropy. Left unchecked, disorder increases over time, energy disperses, and systems dissolve into chaos.

Creativity is the enemy of entropy, bringing order and beauty and hope and goodness and truth into the world. In turn, entropy, and the chaotic, destructive forces associated with it, will try to destroy or prevent any making that promotes shalom.

In part 3, we will look at ten practices that can keep us making until our last breath. But before we consider those, we must recognize enemies that battle against our contribution of art in a hurting world that is desperate for truth, beauty, and goodness. The first, which we consider in this chapter, is *external*: a brutal and narrow marketplace. The second set of enemies that push against our making, which we'll look at in subsequent chapters, are *internal*: despair; disordered attachments that lead us to appropriate others' stories, create

propaganda, or churn out sentimental kitsch; and bad habits of the soul that suck beauty and truth and goodness out of our creative products.

"If you know the enemy and know yourself, you need not fear the result of a hundred battles," wrote Sun Tzu in *The Art of War*. "If you know yourself but not the enemy, for every victory gained you will also suffer a defeat. If you know neither the enemy nor yourself, you will succumb in every battle." The same is true in the war of art: we must know our enemies. Both external and internal opposition have the power to prevent us from making the kind of art that will bring healing to a hurting world. Let's take a closer look, then, at the realities of a calculating marketplace and the truth of our own weak souls.

## Getting Inside the Tent

To promote justice with our creativity, we must enter venues where artists offer work to others, places that buy, sell, evaluate, and rank our art. Galleries, fairs, festivals, shops, theaters, libraries, auctions, collectors, publishing houses, awards committees, reviewers, apps, platforms, and more: all of these mediate a maker's ability to serve the wider world.

The marketplace has power, it seems, to make or break the chances of our justice-promoting art being seen, heard, and received. On top of that, it seems biased toward people with more connections, better qualifications, and the "right"

intersections of identities. How can someone like me access it without getting crushed? How can many of us access it at all? And what is "the market"? I think of it as any space that connects people with art made by other people. For now, let's imagine it as a physical tent full of vendors peddling items like yours to consumers. How big is the tent? Who owns it? Who curates the collection? How is it displayed? Has your art been invited inside to be considered by eyes, ears, minds, and hearts?

Depending on my physical and social distance from the tent owner, curators, exhibitors, and vendors, there may not be room for everything I make—or even anything I make. If and when one of my artistic products manages to get inside the tent, will it be shuffled to a back table, where there's hardly any foot traffic? Will it be hidden behind a large, gaudy piece created by the tent owner's cousin or lover?

Maybe something I create glitters for a moment in the market—suddenly, and to my amazement, it's the hot item that everyone wants. After a while, though, as demand for my art begins to wane, will it be discarded to make room for shinier, newer products?

The poet Emily Dickinson, who is sometimes venerated for not craving popular validation, saw and grieved her inability to reach a broader audience. "This is my letter to the World / That never wrote to Me," she wrote sorrowfully about her poetry, sounding like a rejected lover. Maybe my offering will be like Dickinson's poems, invited into people's hearts and

minds only after my death. But most of us who create art want it to be received while we're alive, and so we must interact with some manifestation of a market.

People on the margins of power typically create without expecting that their art will be appreciated or consumed by outsiders. Their painting, music, dancing, poetry, and stories will likely be received only by a few fortunate people in their vicinity. Rarely is the work of powerless people propelled to popularity, gaining the widespread impact that comes from being celebrated in the marketplace. Making by those who are marginalized doesn't usually remain through history or travel through geographical space. True, it brings flourishing to the creators of beauty and likely to their relatives and neighbors as well; I don't want to minimize the act of doing little things with great love, a practice attributed to Mother Teresa. Yet I do feel a pang that beautiful, good, and true things these people made through the ages and now, in corners and pockets of the planet, aren't received more widely. A biased and brutal marketplace does not offer the same access to all artists. Even for well-educated and privileged me, during three decades of pursuing writing as a career, the market has proved a formidable nemesis.

## The Market and Me

"You've had a good career, Mitali," people sometimes say to me. "You've got a literary agent! You've published lots of

books! One of them was adapted to a film! A few are still in print and read by a new generation of children! What more do you want?" All that is true, on the surface. But in reality, I, like most of my creative friends, have taken punches from the market the whole way. The tent of children's literature has rejected my books, reviewed them poorly or not at all, overlooked them during awards consideration, ignored them on lists and in collections, forced several to go out of print, and sometimes even banned them.

Thirty years ago, when I was trying to publish my second book and knew next to nothing about traditional publishing, the industry seemed even more like an enclave for the entitled. Armed solely by a calling to write books for children that promote justice, I tiptoed near the tent and peeked inside.

I had some credentials: I'd published one book, after all. Responding to a "new voices" contest hosted by Little Brown (the first of its kind in the children's book world, I think), I'd submitted a somewhat autobiographical story about an immigrant Indian girl in an all-white middle school. To my amazement, my book had been chosen as a winner. *The Sunita Experiment* was published in 1993 by Little Brown (now Hachette). It got a few nice reviews but didn't sell very well. Then I wrote *Monsoon Summer*, a novel fully set in India. It was a story about a girl named Jazz, who was shy but entrepreneurial; and generosity; and the power dynamics of giving and receiving across borders in unequal relationships. Into this novel I wove my desire to serve those who are poor, my

education about just development and colonialism, and my firsthand experience of serving overseas. It was a good story, I thought. It was a novel I wanted young people who cared about justice to read.

Little Brown rejected it.

That stung.

But I liked my main character too much to give up. I read books about getting published and sent query letters to other editors. Most said thanks but no thanks. A few would respond by asking for the full manuscript. Each time an editorial letter arrived informing me that the story had promise and that they might buy it if I changed this or that, my heart would leap. Many editors asked for a deep revision after reading the whole book. I slashed, revised, and wrote new scenes as suggested.

But it didn't work.

Still, they came—a parade of twenty-two rejections, first by phone and then later by long, apologetic emails. Those emails grew shorter and brusquer as the years went by until finally "thanks but no thanks" form letters arrived addressed to "Mr. Perkins." Those usually came by snail mail in the self-addressed, stamped envelopes writers used to have to include with submissions.

It was time to face facts: the market didn't want my story. Questions whirled in my mind. This wasn't the non-profit world of development I'd worked in earlier. Publishing was a for-profit endeavor, no matter how much individuals working within it cared about diversity or justice. Was my

novel getting rejected because the powers that be were betting consumers would rather buy books set in the United States featuring white girls born in the United States? Or did my story actually stink?

Five years went by, then seven, and then eleven. *The Sunita Experiment* went out of print. Still I revised and resubmitted *Monsoon Summer*, working on the story during solo overnights in hotels and stolen moments in coffee shops. To check myself, I kept retreating to contemplate if this was really, truly my way of contributing to the planet. "Are you *sure* this isn't a waste of my time, talent, and money?" I'd ask in prayer. There were signs that I should keep trying, but the answer that sustained me came slowly: the craft of writing itself was still giving me joy. I began to employ the practices elaborated in part 3 of this book, and those practices sustained my work in the face of rejection.

Bolstered once again by a conviction that this was my chosen vocation even if it never became a career, I saved money to attend a Society of Children's Book Writers and Illustrators conference. I took the quick demographic survey that a brown woman naturally does on entering a room of American strangers and registered that I was one of the only people of color at the conference. During introductions and conversations, it was clear that, in comparison with other attendees, I had few marketplace connections or contacts.

Nonetheless, I'd paid extra for a critique and had submitted *Monsoon Summer* for someone else's assessment yet

again. My novel was assigned to an established author, a Newbery Honoree. In our meeting, without preamble, he told me that he thought it was good and that I should send it to his agent.

"What's an agent?" I asked, so fresh off the boat he probably got a whiff of sea air from the manuscript he was holding.

The good man hid his surprise at my ignorance and paperclipped a business card to my first page. "Here's my agent's contact information. She'll take fifteen percent of everything you earn, but editors trust her, so she'll fast-track the story. She's not taking new clients, but tell her I read your manuscript and referred you."

Fifteen percent? That seemed exorbitant to someone raised by an immigrant mother who'd once sliced slits in her children's shoes to defer buying new ones. I never called the agent. Only later did I realized this award-winning author had given me a card bearing the name of a *legendary* children's book agent. She was dead by the time I realized what a coup it had been to gain access to her inbox.

Oh, well.

Doors stayed closed.

At times I wondered if I should take the pen name of a white guy, write a novel, and test if my repeated failure to enter the tent had to do with my writing or whether I could blame a market catering to the elite. But I knew there were stories only I could tell, and I had to write them from my own intersection of identities. I soldiered on.

## Rejection and Resilience

When I share this tale with other creatives, they often ask why I didn't see the steady influx of rejection as a permanently closed door to a writing career. All I can say is that I never intended to turn it into my career. Deep inside, I knew writing was my vocation. Every no simply hardened my resolve to get my stories into the hearts and minds of young people. My writing didn't need to reach hordes of them; as I revised and submitted the story over and over again, I'd picture quiet, unseen children like I was as a girl, reading about Jazz and her generous heart.

Maybe being the third daughter in a sonless Bengali village family was part of what kept me trying. As a brown, immigrant, average-looking (which I felt on my best days), modestly dressed (thanks to my culture of origin) girl in the United States, I felt like an unwanted outsider a lot of the time. It was hardly a new experience. I *expected* to be unseen, unwanted, and overlooked. By the time I was approaching the market, selling my artistic wares, I had developed a measure of resilience. In fact, outside the tent was where I was beginning to feel most comfortable creating my art.

I wrote new stories and poems. My creativity was flourishing. On top of that, I was beginning to know and understand the industry. Slowly but surely, I could see my craft improving, and each time I revised the manuscript and resubmitted it, my confidence grew, despite the rejections. I was a

reader, so I knew what I liked, and I was certain young readers would like my book, no matter what the market thought. "I discovered that rejections are not altogether a bad thing," the author Saul Bellow said. "They teach a writer to rely on his own judgment and to say in his heart of hearts, 'To hell with you.'" That's basically what I started doing.

Meanwhile, a steady stream of nos was also coming from literary agents. (By now I realized how these middle-folk could help get my work inside the tent.) Finally, a marvelous person named Laura Rennert agreed to represent me. She read an early version of *Bamboo People*, fiction set along the Burma-Thai border. The subject matter—human trafficking, child soldiers, and refugees—wasn't exactly what the market was clamoring for, but it was a story I felt compelled to tell. My novel made her cry, Laura told me, and she insists that my writing evokes her tears to this day.

A couple of years after Laura agreed to represent me, thanks to her diligence and advocacy, *Monsoon Summer* was finally acquired by an editor at Random House. My second novel came out twelve years after my first one. I was thrilled.

Did I become an overnight star in the market? Nope. Jazz's story made it into a corner of the tent and found a few readers. Then it, too, stopped selling and went out of print.

I kept writing.

I kept learning.

I kept asking God, "Are you sure this is the way I'm supposed to serve?" and I kept hearing, "Yes, darling, it is."

Over three decades, some of my books have sold well, others were sidelined so only a few people read them, and several have gone out of print. I've taken hits inside the tent, including scathing reviews that hurt even worse than the rejections. Novels that I crafted carefully and diligently have fizzled when it comes to sales. Oh, market! How I fear you! How I need you!

## The Market and You

I wonder about your relationship as an artist to the market. Have you, too, shaken a fist at closed doors and cursed the powers that be for excluding your work? Has rejection, bad reviews, or obscurity convinced you that your work isn't good enough? Has the market's response crushed you and led you to stop creating altogether?

If so, I'm sorry. I know how hard it is to sustain creativity in the face of opposition from the powers that be. In part 3, we'll investigate practices to reinvigorate the making of beauty even when the market behaves like an abusive beast. We'll also look at ways to temper a dogged determination with reality when we discern that our making needs a short or long respite from the realities of the market.

External resistance, however, isn't the only culprit that keeps us from making good, true, and beautiful things. We grapple with internal enemies as well—despair, bad habits, and disordered attachments that root inside our souls, taint

our creativity, and prevent us from making the kind of art that will bring shalom.

It's strange, though. Despite the fact that they reside in most human hearts, internal enemies aren't as fierce in opposing making when we don't attempt to access the market. Their ferocity intensifies as we begin to peddle products and continue the longer we profit from making art in any way. We'll take a closer look at these unseen internal enemies in the next chapter.

## Just Needlework

*"When stitching, I feel a strong connection to Bengali women who have created beauty with needles and thread for hundreds of years. Although I live in the United States now, the art connects me to my culture of origin and to the generations who came before me. Continuing this Bengali tradition makes me feel closer to our ancestors—our mother, grandmothers, and great-grandmothers who also stitched.*

*In the moment, though, stitching lets me be me. It calms me. When I am stitching, I forget life's stresses. The colors bring me joy. Creating something from the first to the last stitch is so gratifying. Every movement of my needle brings a sense of purpose as I know that each stitch will end up as*

*part of a beautiful overall picture. I love the sense
of accomplishment when the entire needlepoint is
completed and delight in the reaction of loved ones
when I present it to them."*

—*Sonali Bose, needlework artist and my sister*

# 5

## DESTRUCTIVE INTERIOR FORCES

LET'S NOT MINIMIZE the fact that the market is a tough place for artists. But placing *all* the blame on external forces wouldn't empower us or serve our creativity and commitment to justice. If I'm wasting away in a maker's Margaritaville of mediocrity, feeling sorry for myself and giving up on my art, maybe "it's my own damn fault," as the singer Jimmy Buffett put it. For as long as I've been trying to further the flourishing of other humans with my art, I've also been getting in my own way.

Have you, too, recognized creativity-crushing foes inside your own soul—hopelessness, self-centered motivations, nasty traits and reactions that you're embarrassed to confess because they make you appear petty or selfish? Well, take a big inhale because we're going there. I'll lead the way as there's no doubt my creativity has been assaulted and damaged by insidious foes that dwell inside me.

One enemy is the crushing weight of despair when we are immersed in a world full of pain, grief, and sorrow. Can the making of art make any kind of difference for good? When feeling as if we're wasting time, talents, and treasure, we can revisit the claims about justice and art covered in part 1.

Sometimes, though, words aimed for the mind are not enough. Resisting despair requires engaging the mind *and* acts of the body. We explore a few practices that engage the body in resistance to despair in part 3 of this book.

At times, we also struggle with "disordered attachments" to our own art. What are disordered attachments? Saint Augustine clarified them in his autobiography, *Confessions*, written in Latin between 397 and 400 CE. Applying his principles to the making of art, the right order that leads to flourishing is to (1) love and serve God, neighbor, and self (for the purposes of this guide, feel free to replace the word God with the word mystery if that's more suited to your spiritual journey as an artist); (2) pursue the creation of our own unique, true, good, and beautiful work; and, last, (3) consider the reception it receives. Recalibrating our work based on the likely reception of it is still on the list because considering the needs of our audiences is important and humble work. But it must come last in our list of attachments. When consideration of reception comes before the other two, we lose true North.

When power takes the driver's seat, we can steer the process and product to control, defeat, or dominate. Our agendas, even good ones, can commandeer the making and lead to artistic appropriation, propaganda, and sentimental, mawkish products. Who, me, writing bad stories for the right reasons? Me, writing good stories for the wrong reasons? Me, writing bad stories for the wrong reasons? Yes, I have veered into all three of these errors. Have you, too, in

your field of art? Making justly requires a radical indifference to the values of wealth, status, and power that permeate our era and culture. We must root out the murk in our souls that threatens to squeeze goodness, truth, and beauty from our art.

The first step is to recognize and name the malady inside our souls. As one way to do this, we'll take a look at five of the seven vices first defined by Pope Gregory I in the sixth century, clarified in the thirteenth century by St. Thomas Aquinas: vainglory, envy, gluttony, anger, and sloth. These emerge from Christian moral thoughts, but you don't have to be a Christian to recognize them in yourself. Feel free to call them *bad habits* if you prefer that language.

You may notice that greed and lust are omitted from the list. My vocation of writing books hasn't taken me toward lustful temptation for dalliances on the side (not that it hasn't for others). Nor has it brought the possibility of making me rich! So, gratefully or begrudgingly (depending on the state of my soul), I'll leave the exploration of lust and greed to other makers who have confronted them intensely.

I *do* have firsthand experiences—intense ones—in wrestling with vainglory, gluttony, envy, anger, and sloth. What are these, and how do they manifest in our lives? In what ways do they derail the making of art that resonates truth, goodness, and beauty? In short, these vices or habits keep us from loving ourselves, God, and neighbor through our process and our products. But let's take a closer look.

# Vainglory

Vainglory is "the excessive and disordered desire for recognition and approval from others," writes ethicist and philosopher Rebecca Konyndyk DeYoung in her wonderful book *Glittering Vices: A New Look at the Seven Deadly Sins and Their Remedies*. At first glance, it might be easy to confuse vainglory with simply seeking an audience for our art, which can be a healthy engine of creativity. DeYoung helpfully clarifies the differences among pride, ambition, and vainglory: "The proud person wants to be the director of the best show ever produced, the ambitious person wants rave reviews crediting her work as director from a certain circle of critics, but the glory-seeker will happily sink to new depths of shallow sensationalism as long as ratings will be high . . . the vainglorious primarily desire attention, approval, and applause."

How does vainglory manifest in the maker's life to thwart creativity? Vainglory leads us to assess the quality of our work by the response it wins in the wider world. By definition, then, a person barred from the marketplace due to a lack of privilege might not struggle with this vice as much as I do. But those of us who have been given access to some corner of the market often focus on whether our art is winning awards. Has it been reviewed delightfully in the *New York Times* or lauded by an influential celebrity on social media? Is our work getting that nebulous buzz reserved for the trendiest art or literature?

Recently, for example, I wrote what I thought was one of my best novels. I hoped it might receive some adulation during awards season, but it didn't. After it failed to get as much applause as I'd hoped, I grew grumpy and disheartened. *What's the point of grinding away on a novel when it gets no attention?* I found myself thinking. As the book's sales remained low and I realized it wasn't reaching a wider audience, I almost gave up on writing (for the hundredth time). But after I employed a few of the practices I'll describe in part 3, I forced myself to reread the novel that I'd written. I was anticipating finding fault with it, but to my amazement, I actually liked the story. Nay, I marveled that a weary creative like myself had managed to bring this book to the finish line. Setting vainglory aside (for the moment), I patted the beautiful cover of the overlooked novel . . . and began to work on my next story.

The other effect of vainglory is that we start to create the kind of art we think will be a sensation. We focus so much on fame and fortune that we lose our voice. When we allow the market to determine our art, we begin to stifle the unique identities that keep our craft authentic, fresh, and true. We end up with the most dreaded disordered attachment to our work: making bad art for the wrong reasons.

I understand the artist's temptation to trade everything for a moment in the sun; some of the rationale is financial, and that's valid. But our audiences have short attention spans.

We can't control where their eyes will focus. If we create primarily out of a craving for the public gaze, it's likely that the quality of our products will plummet. The masses, sadly, are usually . . . well, to avoid a rhyming word that might offend, shallow. Chasing the love of a fickle audience can make us lose touch with our own internal compass, our own artistic calling. Again, it leads to disordered attachment.

You might be the exception to this rule. You might be able to create one wildly popular piece of art after another that are true to your voice and resonate with truth, beauty, and goodness. But you'd be singular; most of us can't attain that mountaintop.

"I am the most completely myself when I am creating," says Carol Aust, the fine artist I introduced in part 1. "When I paint, I often tell myself, 'This one is just for me. No one else will see it.' That helps me paint truthfully."

Vainglory robs us of a capacity to create with truth. It keeps us from honoring our art *and* ourselves.

## Gluttony

"There is a God-shaped vacuum in the heart," Blaise Pascal said famously, or at least something akin to it in his book *Pensées.* Pascal's insight leads us to vice number two: gluttony or giving way to addictions in an effort to fill that hole. A couple of my own favorite hole-fillers include food (especially chips, french fries, tater tots, or any form of potato that

isn't healthy) and scrolling mindlessly through social media for hours. You, on the other hand, might stuff yourself by binge-watching sitcoms, shopping, or drinking whiskey. The substances vary, but the end result is a detrimental effect on our creativity.

Gluttony keeps the truth of human emptiness from permeating our art. If we try to stuff that crater in our souls with false fillers, the truth about the human heart can't be expressed through our music, dancing, painting, sculpting, or writing. Those receiving our art need us to grapple courageously with the turmoil of being human, and that includes facing down the void. When we give way to gluttony, we may begin to think there *is* no vacuum because we've stuffed it so successfully we've forgotten it's there. That's when we can end up with art that is vacuous, sentimental, and self-inflating. Gluttony, therefore, keeps us from loving our neighbor with our art. It, too, leads to disordered attachments.

During a recent season of struggle, as I ventured into the deep work of confronting childhood emotional pain, I was wandering alone in the Meijer Gardens in Grand Rapids, Michigan, seeking solace in art. When I saw a sculpture by Auguste Rodin, one of twelve known full-scale bronze casts of *Eve*, I had to turn away at first. Head bowed, trying to hide her body with her awkward posture, the female figure is barely staying upright. Instead of standing rooted and secure, with her entire body weight supported over one straight leg in a classical *contrapposto* position, she cowers. The sculptor had so

powerfully expressed my own state of shame and fear of being exposed that I couldn't even look.

But as I stayed and forced myself to take in the lines and curves of her posture, I felt a strange solidarity with the woman Rodin was presenting to me. It was as if her twisted condition was strengthening me to endure my own. I wonder what might have been rendered instead if the sculptor had succumbed to gluttony, numbed his pain, and refused to face the tender vulnerability at the root of human experience.

One caution, though, when it comes to being rigid about rejecting false fillers. Artists are not immune from depression, anxiety, and mental health issues. Many artists need some form of medication to endure the pain of the human condition. The key is moderation: survival of our artistic voices without silencing or subduing them with substances. We'll talk more about this in part 3 when we look at practices to help us grapple with gluttony.

## Envy

Now we confront what is perhaps an even uglier vice: envy. This one is accessible to all makers—those with privilege and those without. While vainglory turns us into Labrador retrievers, wagging our tails for attention, in the grip of envy, we become pit bulls in the dogfighting ring.

Envy is a zero-sum game of lovelessness: my neighbor's win means my loss and vice versa. Maybe you have your own checklist of signs that can reveal this scarcity mentality. Mine

manifest as covert visits to Amazon to check my competitors' book sales rankings. Next comes the twisted pleasure if my book is ranked higher than theirs (ugly, I know) or the jolt if theirs is outselling mine exponentially (usually the case). During awards season, when they win, I want to be happy they won. I may even post about that happiness on social media (failing to mention that the so-called joy I avow on their behalf is more aspiration than reality). But let's be honest: it sucks to lose. Inside, I'm envious, and envy does not allow me to love my neighbor.

As I keep succumbing to it, envy thwarts my making by twisting my soul into a shape that can't make goodness. Even when we *win*, envy can still prevail; it simply turns itself inside out and becomes gloating over our triumph. In the throes of *schadenfreude*, which means rejoicing in another's downfall or misfortune, we still find envy seeping into our art. Like vainglory, envy also keeps us from attaching properly to our art. Instead of celebrating our work, we denigrate it because it didn't edge out another's. The truth is, akin to people, any creation we make in the pursuit of goodness has dignity, regardless of whether it wins or loses.

In my village Bengali culture of origin, an envious person is rumored to have the evil eye. To avoid garnering the attention of this malign gaze, a mother might slight her child's appearance publicly, or a husband might loudly insult his wife's cooking. In the same way, envy can be an internal evil eye, leading us to condemn our own dear art in comparison

with another's. Such an inward malign gaze will eventually result in our creativity cowering and shriveling.

I wonder at artists throughout history who kept making even though it would have been easy to let jealousy or bitterness consume them. You might have seen or heard of the classic film *Amadeus*, which tells the story of Antonio Salieri, a composer reportedly consumed by envy of Wolfgang Amadeus Mozart. The movie illuminates clearly how this vice robs an artist of the joy of making (although in truth, Salieri did manage to create 652 total works).

Someone needs to make a film about Florence Price, a composer who lived in the first half of the twentieth century. Surrounded by white male composers born with proverbial silver spoons in their mouths, Price fearlessly and tirelessly kept creating. She composed more than three hundred works, a miracle given her lack of support and the trials she endured as a woman of color trying to succeed in the field of classical music during that time. Envy surely could have hindered this prolific creative, given the odds stacked against her, but she resisted giving way to it. She kept making and took joy in it. Price wrote this to a close friend, "I found it possible to snatch a few precious days in the month of January in which to write undisturbed. But, oh dear me, when shall I ever be so fortunate again as to break a foot!" She composed her first symphony, the "Symphony in E Minor," during her recovery from this injury; it won a competition and became the first work by a Black woman to be performed by a major American

symphony orchestra. In Price's life of deep faith, we see results that only come by taming envy.

## Anger

Like envy and gluttony, anger is universal. Every human heart experiences it, and even divine beings are recorded as feeling it. The emotion is unique, however, in that it's deeply intertwined with our love of self and neighbor. It is right to fume at unfairness in the world, hate injustice we experience or see in relationships around us, and be angry at ourselves for our own contributions to others' suffering. Righteous anger can spur us to make revolutionary art that agitates for change. It can propel us to put our creativity to use to fight for a good cause. Our call is not to separate ourselves from anger but to channel it for justice.

The problem is that this vice, when unrestrained and unmoored to goodness, can also lead us to fight poorly for bad causes—or even for good ones. When our anger becomes a free-floating thing, tethered to nothing but itself, we might end up making propaganda to fortify oppressive people or systems, hurt others, or simply justify ourselves. Unfettered anger destroys the well of love we must draw on to create just art. Unresolved bitterness or rage can choke creativity like garbage in a stream.

Again, we can put practices in place that will help restrain these effects. And the good news is that as it's channeled into

the making of art, our anger can heal ourselves and others. In 1611, Italian painter Artemisia Gentileschi was raped and forced to endure a traumatic trial. Eventually, she channeled her rage into her paintings. Her work often portrayed women resisting and overcoming violence and oppression. If you want to feel the satisfaction of seeing a violent man stopped by a powerful woman, consider the painting *Jael and Sisera*, painted in 1620 by Gentileschi and depicting a woman whose story is told in the Bible's book of Judges. The upraised, strong arm of Jael about to issue her fatal blow resonates like a life sentence issued by the arm of justice to an evil perpetrator.

## Sloth

Sloth is perhaps the most insidious, ubiquitous enemy of making and the easiest to identify in ourselves. Sloth, for makers, means simply not creating because . . . well, because making stuff is hard. Art depends on a slow, daily slog of showing up. Sloth opposes any kind of diligent, quiet, faithful love. It puts an end to the training required within any art genre.

For all the delight of flow discussed in part 1, sometimes the wonder of making comes and sometimes it goes, like passion and ardor in a marriage. The rest of the time, we stay put because we made a promise. And we work at it regularly because without discipline and investment, the gift of

creativity will dwindle and disappear. We lose out on love, and so will our neighbors.

And now we've reached a place in this book where I must confess the truth: sloth has been a constant, unrelenting foe in my own making. I know people who wake up at 5:00 a.m. and write diligently and lovingly. They nurture the work daily, keeping that promise they made when they first accepted this vocation. Me? Not so much. My editors and agent learned that unless they set a firm deadline, my creative juices won't flow. In school, I was a last-minute procrastinator; I still can't get to a finish line without a proverbial gun to my head. Weirdly, thanks to the burst of adrenaline that arrives before a due date, I have managed to complete projects, but sloth in my process leaves a vile voice in its wake: shame. As a book goes to print, I find myself wondering this: What if I'd worked harder and more faithfully? Would my product have more impact? Did it miss its potential because of my sloth?

"Through my fault, through my fault, through my most grievous fault" comes the refrain in my brain, as shame causes me to devalue myself and my art. And . . . I'm back to dis-ordered attachments because self-denigration reveals a twisted version of pride and an absence of gratitude. Yes, I'm weak. Yes, I fall short, and so does my work. The truth is that I'm dust. By grace, I breathe and create. What a miracle it is that I make anything at all! This book, like all my others, is flawed and not as good as it might have been if I were a more virtuous human being. But here it is; here am I. Somehow, let justice roll down.

## Sustaining Just Making

Even as we accept our shortcomings, we must continue to struggle against interior opponents. Creativity expert Richard Holman exhorts us to do what he calls "checking our demons." "The longer you leave your demons unchecked, the more they will thrive and the bigger they will become," he writes. "Fail to confront them and they may completely overwhelm your creative impulses . . . (they) will paralyse you, and that triumphant, life-affirming feeling of stepping back from the lyrics you've just written, the pot you've just thrown or the image you've just drawn and thinking 'I made that!' will never be yours."

But how do we restrain such insidious foes? Read on, compassionate, courageous friend. We're about to explore some practical ways to oppose both external and internal forces that prevent our just making.

## Just Composing

*"In the main, the world of Florence Price's art songs reflects the landscape of her greatest hopes and creative visions—there are just a few of her songs that give us a window into her personal suffering. 'Resignation' is such a piece: an original work written like a strophic spiritual, the piece tells a story of immense heartbreak and weariness; it is a devastating portrait. It stands in contrast with many of Price's original songs that tend to reflect her dreams and her vast imagination,*

*with quite a bit of romantic charm interwoven. She is a master of economy, too: most of her songs are just two to three minutes long, and yet they transport the listener entirely in such a short span of time!*

*I feel connected to Price's songs on many personal levels. As a Black and biracial woman like Price, and also as a woman of some reserve and introversion, I admire the perseverance with which she clung to the world of her dreams despite the profound challenges that she faced throughout her life and career. They kept her afloat; they buoyed her spirits as a lifelong creator, as a mother, and as a friend. I am a fervent optimist too—it is that lens that helps to lift me up in the hardest of times, especially when I fear that echoes of trauma will haunt and limit me forever. I turn to the wisdom of my ancestors, especially to our beloved family matriarchs, and feel energized by their will to live, their tirelessness in fighting for a brighter world for their sons and daughters, their insistence upon nurturing as a foundation for a kinder sort of life to build in loving community.*

*Florence Price was a survivor. She was a soft-spoken warrior. She was a nurturer. And she reclaimed her right to live with joy and delight again and again. The wondrous soundscape of her song literature reveals the great breadth of her imaginary life—in the world that she believed in, there was*

*birdsong and a soft southern breeze and the scent of peaches in the air. It is there that she plants her seeds and brings her full vision to fruition. What lucky listeners we are to witness her inner transformation!*

*Every time I perform one of her songs, I feel that profound healing at work. It feels like revisiting a friend. The kind of friend who's been walking beside you for your entire life, whether you knew it or not, reminding you to keep your chin up and lift your face up into the sun."*

—*Michele Kennedy, classical vocalist*

# PART III

## HOW TO KEEP MAKING

# 6

## RESTORE AGENCY IN THE VOCATION

WE'VE CONSIDERED WHY making art is so crucial in the healing and flourishing of ourselves, our neighbors, and a hurting world. We've taken a closer look at some of the enemies that keep us from generativity. Hopefully, then, having been bolstered by the call to foster shalom and keenly aware of the forces arrayed against that effort, we come to the practical part of this guide: *how* do we keep making art that promotes justice when grappling with enemies without and within?

Despite the support I've received during my career, I still often feel like the market is the major opponent. I've sulked and whined and wanted to shout when it refuses to buy and sell my art. I've felt rejected by venues that aren't interested in connecting my work to a wider audience even when money isn't exchanged. Maybe you have too. Being denied access to the receivers of our art by the all-powerful market is demoralizing to the soul. Such external opposition fuels the internal enemy of despair, which threatens to overwhelm us already, given current events and the human condition.

Because you've opened your heart and mind to this book, my guess is you have a desire to promote justice and a conviction about your vocation of making. How can you keep trying

ATTENTION SHOULD BE
CALLED TO PRACTICES 1-3

POORLY ORGANIZED

to make justly when the doors to sharing your art stay closed and the world is on fire? In this part of the book, we'll consider ten practices that help us stay purposeful and clear-eyed when we feel hopeless about creating shalom through our art. In this chapter, we explore the first practice, which involves working on areas related to the market over which we *do* have agency: craft, rules, and relationships. In chapter 7, we'll look at a second market-defying practice: seeking third places to share art. Then in chapter 8, we'll unpack another: seeking mentors in the margins. In chapters 9 and 10, we'll dive into the remaining seven practices that take on interior enemies like despair, disordered attachments, and destructive habits.

Let's start with *practice #1: restoring agency in the vocation.* There are three prongs to this first practice: work on craft, master rules, and build relationships.

## Improving Craft

As we circle the market, hoping for entry, we don't just sit helplessly wringing our hands while we wait for doors to open. The practice of regaining a measure of control in this imbalanced relationship begins with honing our craft. During the many years of rejection I described earlier in this book, I found solace and maintained momentum because I was seeing my writing improve. Even though I wasn't yet reaching readers, the work I was generating was getting better. After each round of revision, once I set aside the work for a while before

returning to it, I could see with fresh vision that it might have a more heart-widening impact in the long run. I began to honor this improvement, celebrating even bad first drafts and revisions that improved them.

Our creativity is valuable and precious in God's eyes and so deserves to be seen and celebrated. "It is good," the Creator said after making beautiful things. But in an astounding measure of divine humility, God continued to work with chaotic collaborators—us!—to restore order and beauty. In the same way, we can celebrate instead of despising even rough, wince-worthy drafts. We made something! We didn't just loll around and consume—we actually created. Hooray! Look at us! Look at what we made! We clink flutes of frothy liquids . . . and then return to improve the work.

We can celebrate both the making and the fact that we must make our art better. "Writers, composers, choreographers, painters, and sculptors all aim to establish a solid foundation for their imaginative flights," writes Jed Perl. "An argument can be made that the wilder the flights the more solid the foundation needs to be." This foundation is the craft itself. We learn the basics and apply what we've learned to our work.

After honoring my first efforts despite their mediocrity, I could see that I needed to fork over money and set aside time to improve my writing. I'm a frugal person, so financially investing in unprofitable writing seemed frivolous at first. But I came to see it as a talent that needed to be stewarded for potential future

payoff. I reminded myself that what we make matters greatly in a suffering world. I took classes, read voraciously, and studied classic and contemporary books for young readers.

Whatever your genre of art, I encourage you to do the same. It's easy these days to find classes online taught by experienced artists unless you're on the other side of the digital divide and far from a library (we'll talk about creatives without access or resources in a bit). Find such classes by approaching other artists on social media or online and asking for recommendations.

If you're reading this guide, I'm assuming you have access to books too. Even so, if you're either broke or else cheap like me (I get you), tuck an empty jar in a corner of a desk or set up a fund on an online money app. Then each time you forsake a coffee, a drink, or a treat, store the monetary equivalent in the jar or app until you've gathered the amount needed to enroll in a class.

This process of improving craft, however, demands humility—to be willing to change almost everything in pursuit of excellence. We open ourselves up to criticism and praise and consider both positive and negative feedback—even as we develop a strong inner voice that can sift through the opinions of others. We treat our art as we would treat a beloved friend who is seeking maturity. For this friend, we set aside time to play and regain the joy of flow.

Making space and time for play can be a stewardship investment too. Take your calendar and pencil in monthly or

quarterly periods of time labeled "date with my muse." These scheduled meetings can last as long as one hour or one week. Sometimes shorter spans of time actually thrust us into flow better than longer ones. When I was a mother of young children, I only had enough energy and time to squeeze in a short writing burst every week. The good news is that ten or fifteen minutes is all a brain needs to get into flow and thus into the mode of play.

If at all possible, find a separate geographical space to have this play date with your craft in solitude. Now that I'm an empty nester, I escape to a home by the sea provided by a generous friend. There I get to spend time savoring the sheer fun of writing. I put the intrusive, invasive internet out of reach. I think of this time almost like a real date, during which I'm cherishing, flirting with, and wooing my muse. Glancing at my phone mid-date is a deal-breaker for this elusive, hard-to-get, but oh-so-magnificent date.

Along with investing time and money in learning and playing with craft, we learn from studying the art of others. Gleaning from their excellence, we improve our own work. The process of considering art in the same genre as ours, though, shouldn't lead us to dismay or defeat because another artist is so much better at it than we are. As we receive and reflect on products made by creative peers, in both the present and the past, it's a way for our own unique voices to mature. Where do we resonate with joy with this piece? Where does it collide with or result in dissonance with my senses or sensibilities?

(Thank you, Ms. Austen.) Where does it speak to me about goodness, truth, and beauty? How does it fall short?

As we invest money and time in our craft and reflect on the magnificence of art made by others, punches from within the market begin to lose power. We make because we love it and were created to do it. Experiencing continued delight in making is the best way to constrain the market's power over our art. We're going to get better at it, even if nobody within the tent is ready yet to celebrate it. Our art is improving, and that's good work.

## Learning the Rules

But oh, the market. There's the closed entrance into the tent, out of reach, a crowd of other wannabes blocking our way. What's next while we await admittance? Along with investing in craft, we master the rules inside the tent.

How does one go about submitting work for consideration in your genre of art? In my field, we send query letters to agents or editors. This means learning how to compose pitches. It involves polishing and revising each submission to be compelling and engaging and free of grammar and spelling mistakes. It requires sending personalized query letters to an editor or agent to show that we understand their unique mission and vision. "I've read three books by clients you represent, [title, title, title], and I can see that you are drawn to stories that are page-turners when it comes to plot but also

feature likable but flawed characters. My novel, [title], fits this description . . ."

Your own arena of art will have rules of entry and a code of inclusion that you can understand while you wait. We can resent and resist these rules all we want, but learning them is usually the price of admission.

## Forming Relationships

As we all mill about outside these tents, we also cut a bullying market down to size by developing collegial relationships. Yes, we care about gatekeepers who are inside the tent. At writers conferences, I see writers fawning over editors and agents (I've done some of that myself, and I'll even confess to cornering an editor in a restroom). But in truth, the most important and powerful relationships we make are with fellow artists.

Other writers have helped me comprehend and navigate the vagaries of the industry, shared keen insights into how to approach gatekeepers, and celebrated and championed my work. Most importantly, however, they provide encouragement and solace in community when it comes to pursuing shared goals. Only those of us trying to access a particular market understand the intricacies of this somewhat adversarial dance; as we link arms, we stay in step to a tune that seems discordant at times.

These relationships are akin to the historical idea of a guild, which brought artists together to give them power

in the market. The Guild of Saint Luke, for example, was a common name for a collaboration of painters and other artists in early modern Europe. They were named after the Evangelist Luke, the patron saint of artists. Other guilds unified artists across genres. "Painters, Sculptors, and Architects are in danger of settling permanently into three distinct professions, oblivious of one another's aims," wrote the founders of the Art Worker's Guild in London, which still operates today, uniting four hundred artists across different genres. "A Society is wanted to restore their former union with one another."

These days, guilds are experiencing a resurgence. I find this a hopeful sign. Such affiliations lead us to pursue publication in anthologies, share poetry at open mics alongside other poets, display in a collective show, train the next generation of artists, and present on stage in conversation with or on panels with colleagues. I recently applied to join the Redbud Writers Guild because I resonate with its mission: "We envision a vibrant and diverse movement of Christian women who create in community and who influence culture and faith." I'm just beginning my affiliation with fellow members, but their welcome and support have already bolstered me in my work. If you can't find an existing guild of artists, why not launch a new Guild of Saint Luke or something akin to it?

If we don't have time or energy for that kind of leadership, forming or joining an informal collective can also serve an important purpose. A few years ago, a fellow children's

book writer created an online group of traditionally published career authors. We gather once a month to share our highs and lows in the profession, talk frankly about market realities and opportunities, and share financial information as well as details about contracts our agents have managed to negotiate with publishers. This shared knowledge has empowered all of us, including and perhaps especially me. Even after all these years in the industry, the immigrant-child part of me still needs support and encouragement to take on the powers that be. When I hear about how my colleagues assert for themselves and their art in the market, it gives me courage to advocate for my needs and wants in new ways.

If we're fortunate, we can receive support from patrons as well as peers. I realize this isn't the Renaissance, when the House of Medici sponsored most works of Florentine art and artists received commissions in advance. As my career has progressed, however, I've benefited not only from the generosity of my husband but also from grants, fellowships, and residencies set apart for writers. These weren't coming my way when I was starting out, though. The majority of novice artists today have no patrons (apart from a few with wealthy spouses who pay for food, clothing, and delightful writing cottages in the woods). I dream of faith communities and community centers supporting beginning artists by providing funds, space, and time. Such modern-day patrons might host a childcare collective that gives young parents a couple of hours a week to make in quiet spaces set aside for their work. They can sponsor an

annual artist's residency by providing a stipend along with the affirming title of "artist in residence" on the website.

It's worth taking stock of how any institution with which we're affiliated values artists. Doing justice through making art becomes more conceivable when a creative feels the support of a community. It's in community that we restore agency by improving craft, understanding the rules of the market, and forming the collegial relationships that will sustain us in our quest to gain an audience for our art.

But is the traditional market the only way to reach possible recipients? May it never be. Artists have always found ways to sneak around tents controlled by insiders. And in the fluidity of the digital age, traditional markets are losing even more institutional power. This takes us to our next market-defying practice: finding third places.

## Just Design

*"How does my creative work promote justice in our world? I feel like framing it in that way can be reductionist and limiting. I have made art that specifically and intentionally looks at justice—from kids' book illustrations literally about judges and questions of right and wrong to linocut prints dealing with pornography, abuse of women, drunkenness, prostitution, and murder. But I maintain that it is*

*better to step back and look at beauty and justice and artmaking from a more holistic perspective.*

*I am convinced that in the 'fittingness' of our artmaking, we create a picture of reality in which injustice seems so incongruous that eventually no one will be willing to stand for it. In* It Was Good: Making Art to the Glory of God, *I write, 'The word used in Genesis 1 for* good *in the Hebrew is* t.o^b- *(pronounced "tuv") and conveys the broad meaning of that which is good, useful, and especially good morally—while also conveying the aesthetic moment of beauty.' When we make art that is good, we are adding to the beauty in the world and, in doing so, making something that can be morally good and useful. And hopefully . . . even just."*

—*Ned Bustard, illustrator, graphic designer, curator, author, and printmaker*

## 7

# FIND THIRD PLACES

I WAS AT a restaurant not long ago that was showcasing and selling the work of local artists. As I walked around, taking in the work, I was drawn to one piece in particular. It was an oil painting of the chapel on the campus of Saint Mary's College of California, the San Francisco Bay Area college where I taught and where our boys attended. My eyes delighted in the familiar white chapel, framed by oak-studded hills, and the bell tower with arches and red Italianate tile rising against a blue sky. In the forefront of the scene were a lush sward of grass and a black statue of a reading Saint John Baptist de La Salle, patron saint of teachers.

The painting reminded me of the Saint Mary's students I taught (including our sons, who both took my courses) during that special season of life. The colors sang with the delight I felt when walking there. *What a rich sense of place*, I thought. I bought it and started following the painter, Kerima Swain (read her contribution to this book at the end of this chapter). Kerima is not famous in the "celebrity" way we think of that word—not yet anyway. But as the poet Naomi Shihab Nye puts it so beautifully in her poem about fame, "The bent photograph is famous to the one who carries it / and not at

all famous to the one who is pictured." So in a sense, Kerima *is* famous because I cherish her painting and it brings me so much joy.

Interestingly, I discovered the piece not in an exclusive gallery but in a local restaurant, a "third place." In sociology, this phrase refers to a social environment that is separate from our home ("first place") or our workplace ("second place")—which, for an artist, includes any market controlled by the art industry. *Practice #2 involves finding third places.* When an uber-selective market has no room for our art, we can approach third places to host and connect our work with a potential audience. Third places include libraries and community centers, churches and local businesses, and digital spaces online as well. What if we were to begin looking at third places as venues to host our art and connect with other makers and other receivers?

In his 1989 book, *The Great Good Place*, Ray Oldenburg argues that third places are important for civil society, democracy, civic engagement and for establishing feelings of a sense of place. Examples of third places include churches, coffee shops, bars, gyms, community centers, libraries, bookstores, restaurants, parks, theaters, office lobbies, and performing arts buildings, among others. Some of the characteristics Oldenburg uses to identify such spaces include a group of welcoming "regulars"; a cozy, wholesome, and not grandiose vibe where banter and wit can flow freely; and a feel of warmth, possession, and belonging for people who show up. So how do we

identify such places in our reach—and which ones might be right for our art?

You, like me, might prefer local, in-real-life venues that meet Oldenburg's criteria. Since he coined the phrase, however, new third places have multiplied online. Some artists even see virtual spaces as a better match for their personalities and genre of work. Let's look at some of the pros and cons of each kind of alternative to the traditional market to help us decide whether one or both might be a fit.

## Virtual Third Places

How might virtual platforms serve as third places, especially when it comes to the arts? What are their limits and benefits? Morgan Kasprowicz addresses this question in an article called "Third Place Theory and Virtual Platforms: How Arts Organizations Might Build Community Online" by revisiting Oldenburg's criteria and seeing how well virtual places meet them:

> *No matter the setting, third places are recognized by the quality of the environment they create. Third places are natural social levelers that invite people to connect across lines of social or economic difference. They are widely accessible "homes away from home," where visitors can escape family or work-related roles. Third places invite casual, chance conversations over common interests or experiences. For any space to*

*function as a true third place, all of these conditions must be present . . . to fully meet Oldenburg's criteria (and create utility for arts organizations wanting to foster virtual third place environments), in addition to providing an environment for spontaneous, real-time interaction, any virtual third place must also center conversation as a primary activity, not just a likely byproduct.*

Apart from the reality of a digital divide that keeps less privileged recipients from art shared online, virtual third places offer access to those who are homebound or in geographical locations where such artistic spaces are few and far between. They are available to those constrained by duties that keep them elsewhere or unable to afford entry to local third places. Any of these might apply to you. Or maybe you find that face-to-face encounters in real time induce too much anxiety. Kasprowicz points out that it might be *easier* to have free-flowing conversation in virtual spaces, especially if an organization can monitor entry to create safety for artists. "Interestingly, some research . . . suggests that the freedom to engage through anonymity or 'alternative personae' in virtual spaces creates 'less inhibited' and especially 'spirited and lively' conversations," he writes. "In other words, despite the clear differences and limitations of virtual worlds, virtual platforms may also have some advantages over physical settings for conversation generation."

One of the downsides of virtual third places is that when disembodied and separated by screens and hidden behind usernames and avatars, virtual recipients feel freer to release soul-crushing criticism. It's also easy for online receivers of art to become a disconnected audience whose praise has less of an impact from a distance. We need to discern whether words of criticism and praise are more powerful when responses are delivered online or face to face. Scathing reviews hurt, so how thick is your skin in either situation? Honest praise can fuel your making, so which venue is conducive to receiving it with the most effect?

Virtual spaces may also leave us more vulnerable to the hope of succeeding in the wider marketplace. There's nothing wrong with trying to use a small, virtual marketplace to gain wider impact. But if that's *primarily* why we're sharing our creativity online, let's identify it as an effort that's distinct from a third-place practice, which provides space for art to be presented and responded to in smaller communities. In other words, if we're motivated to share our art virtually by the long shot hope of reaching a more powerful marketplace, it's like we've joined the sweaty crowd thronging in the waiting area of a singing competition television show, wanting desperately to be chosen.

A virtual launch *might* lead us to the miracle of a viral success that reaches ears and eyes of gatekeepers in powerful, more selective markets. Wonderful! But the odds of this are low. We celebrate the outliers who gain this outcome. For the rest of us, however, as we approach virtual spaces with humility and self-awareness, we begin to notice the buzz we get from

likes and shares. We begin to pay attention to the way virtual feedback begins to feel like an addictive substance instead of the pursuit of shalom. And we temper aspirations for wider acclaim with the satisfaction of sharing creativity with a few who encounter it online. When we do these things, virtual spaces can indeed become akin to a neighborhood third place.

## Neighborhood Third Places

What can local third places offer that virtual ones lack? Sharing art in an embodied, local setting can tame the creativity-thwarting effect of rejection from an all-powerful market. As we discussed earlier, our art and our making are fragile; they need active defense. That's why incubation in a space where we see and hear the reactions to our creative products in real time is a helpful practice. Maybe this will bolster your making as it does mine. In a local space, as we take in recipients' verbal and nonverbal responses to our art, we experience and receive in the present moment the effect of our creativity. Without minimizing the delight of seeing our work enjoyed and received online, the refreshment we receive when sharing it in person lands differently for the artist. Watching friends' and neighbors' faces as they hear you read your poems at the local library, walking through an independent bookstore hosting your work alongside that of other writers, seeing how a child responds to your sidewalk art display—these are the delights of sharing art in third places.

There's something truly mysterious and marvelous about blessing our in-real-time neighbors with our creativity— people with whom we share a particular location at a specific time in history. They are the ones we are perhaps called first to reach with our art. I've experienced the refreshment of embodied local sharing in my own life as an author. Sure, a few of my books have reached children around the world. But when I read one of my books aloud to a particular child nestled in my lap who is receiving it with delight, I emerge with a renewed connection to my story. *— Who?.*

Localism as a way of life, I'm glad to see, is rebounding in some communities as a writer describes here: "Every now and then an individual or group of individuals is vaulted into a position of more reach. However, by and large, we are creatures on a small parcel of land with a few feet in our wingspan, and a handful of people under our care. . . . The 'smaller world' that modern technology has afforded, in its speed of travel and even faster rates of communication, has exacerbated these antirealities. The power of the locale has been rendered unintelligible at just the moment when it holds out for us so many remedies."

In my Bengali culture of origin, one of the first questions we ask when meeting another is "Where's your *desh*?". *Desh* is loosely translated as *village*: the place where we belong and where we are known, where we understand the terrain and climate, where our great-grandparents played games and climbed trees. My theory is that most of the loneliness in the

urban, industrialized world stems from a disconnection to villages rooted in culture and language. I see a constant striving and hunger for localism in people cut off from the villages of their origin. By sharing our art in neighborhood third places where we live, we help ourselves and our neighbors feel the spirit of *desh*.

## Art for Bread

Here's a quick word about making income if we pursue alternatives to traditional markets. The truth is that old-school galleries, publishing houses, theater companies, movie studios, and such will likely afford to pay an artist more than any third place can. It may not matter to you if and how much money you receive, but most of us do our best to earn something for our work. We need to put proverbial or actual bread on the table. So how do we start to earn income by using third spaces?

When it comes to making money, virtual small markets can outshine local ones, so we offer our work for sale in both venues—virtual *and* local. With virtual spaces like self-publishing sites or online maker galleries, the bar to entry is lower. Almost anyone can upload something to be perused by potential consumers, but selling art or books online means grasping the nuts and bolts of technology. How does an artist or writer set up payment if someone buys one of our products? Most of these sites are fairly easy to use, but there's always the option

of asking a tech-savvy friend or relative to walk us through the steps.

I'll share two guidelines to approach neighborhood spaces, where the challenge to display and sell our art is greater. First, we gather the courage to approach the proprietors and guardians of these spaces to present a proposal for art sharing. This might mean steadying your nerves and calling the owner of the café in your town to ask if they'd consider hanging your watercolors. Or stopping by the librarian's office at your public library and donating a copy of your self-published poems and then offering to host a reading or an open mic for other poets in the community.

Second, we go to bat for our work, treating it with the dignity it deserves. We are not beggars; we are givers. We are offering this third place the privilege of hosting our work. We price the work in line with research into comparable products. And we aim high, letting the small markets of these local spaces tell us if we've priced too ambitiously. Their response may shatter our expectations and prove instead that we've set the bar too low. "It is good," God said of God's own created work, and we echo that validation when we advocate for our own product, despite the flaws and frailty that we so clearly see.

While we might make a bit of income and gain some exposure, third places aren't likely to lead to fame or fortune. Every now and then, an individual artist or group of makers is vaulted into a position of more reach: the novelist

gets the huge book deal, the sculptor gets the installation at a major museum, or the actor gets the lead on Broadway. On the whole, though, third places ground us in making with humility—a word connected to the Latin word *humus*, or the earth where our feet walk. This quality is essential to keep making just art, as we'll focus on in chapter 9.

There's an upside-down principle at work here: when we loosen our grip on the desire for a grand stage, focusing on principles of justice and shalom as part of making, creativity flows a bit more naturally. Essentially, when it comes to human flourishing and the promotion of justice, it doesn't matter how many people receive our art. I'm a believer in the magic of one story that changes the life of one child, multiplying flourishing to many through a ripple effect. Practically, though, I feel a sense of dignity when I'm paid to write it.

Kerima Swain's painting of the St. Mary's chapel now hangs on my wall. I'm grateful that the restaurant hosted a showing of her artwork and that I happened to dine there while her work was hanging on its walls. Now, every time I look at it, it brings me a sense of rootedness and a dose of joy. When I interviewed Kerima for this book, I wasn't surprised to discover that, like me, she is an immigrant. Perhaps at some deep level, my soul resonated with her outsider's view of our adopted place, the beautiful Bay Area hills.

This leads us to the exploration of a third practice, one of my personal favorites in its capacity to keep me making and

build hope: receiving and contemplating art made by mentors in the margins of power.

## Just Painting

*"Ever since I was a toddler, I have loved making art. However, growing up in Taiwan with parents who were teachers and engineers, I was encouraged to excel academically. In a culture that viewed an art career as economically unviable, becoming an artist never crossed my mind. Instead, I planned to become a doctor or an engineer but eventually pursued art-related careers in graphic design and art therapy. After witnessing the transformative power of art in my clients, I began to create a lot more art myself and started taking painting classes.*

*Initially, I painted for personal healing and enjoyment. Over time, I gained the confidence to share my art and started showcasing my work in galleries and public spaces. After over 30 years in art therapy, I retired to focus on painting. Most of my current artwork consists of landscapes from the Bay Area, the beautiful place I now call home. Even though I immigrated over 40 years ago, I still find the different scenery here refreshing and inspiring.*

*In a world filled with chaos, pain, and injustice, I sometimes question if it was selfish*

*to devote most of my time to my art rather than continuing art therapy or pursuing another seemingly more meaningful path. During these moments of doubt, I remind myself that art-making is a source of healing and well-being for me. As a valuable member of society, my own peace and health matter and can radiate outward. Thus, creating art is not selfish. Sharing beauty can bring joy, peace, and healing to others, making a significant contribution to the world."*

*—Kerima Swain, painter*

## 8

# SEEK MENTORS IN THE MARGINS

AFTER THEY WERE displaced from their ancestral land by the establishment of a national wildlife park, the Tharu people in Nepal have struggled to find streams of income. For girls and women with nimble fingers and an artist's sensibility, weaving baskets is one way to earn money. Woven from bamboo and rattan and silver grass or other materials, each basket can take up to a month to complete.

But here's what captivated me as I perused their products: the artistry of each basket. These women are not just making the same basket over and again to sell for the purposes of utility. They're not simply mass-producing what the market wants. As I take the time to contemplate the baskets, an individual artist's creative vision becomes visible. The products are unique when it comes to patterns, colors, and textures. Each was designed by the maker and required time and thought and artistry to make a useful product beautiful. A Tharu basket hints at a Divine Presence who is still working with human makers to weave order, truth, and beauty in a world of chaos, lies, and ugliness.

These days, Tharu women are making a bit of money and reaching limited markets. But for generations, their

ancestors kept this form of art alive without any hope of income at all. They persevered in making through desperate circumstances. Those of us in more privileged places who wrestle with despair over injustice in the wider world, facing the discouragement of closed doors in the market to our art, can watch and learn from these artists. We can contemplate the beauty and elegance of the functional products they make under such duress.

This leads us to *practice #3: seek mentors in the margins.* When voices in our heads scold us that creating beauty is a waste, or when they hiss that injustice and chaotic current affairs can never be righted by art, a powerful practice to quell their ferocity and deception is to consider less powerful makers—in the present and the past, close at hand and far away. These courageous souls made art with no hope of fame or fortune. They had limited access to time, money, materials, training, connections, and third places, whether local or digital. They may not even have had physical safety or a home because of war, persecution, or other violence. Yet they kept making.

These are mentors for us—creatives who lack resources that we mistakenly feel are necessary to create art that brings shalom. As we consider the authority and bravery of artists without social or political power who created art in anonymity, we distance the act of making from the receptivity and admiration of an audience. Their bold act of creating beauty, truth, and goodness despite suffering in their lives can fuel our own making in hard times. We take time to receive and

admire their products, and the art itself builds hope about human resilience.

In this contemplative practice of receiving art from makers in the margins, it is wise to choose some made by females because the chances of women succeeding in the marketplace are significantly lower than for men. Jane Chu, an artist who served as chair for the National Endowment of the Arts from 2014 to 2018, highlighted this discrepancy. "Less than 25 percent of produced plays are written by women," she writes. "Women artists make up only three to five percent of major art museum collections in the U.S. and Europe. In films, female characters receive about half the screen time and dialogue as male characters." As we look for inspiration in this work of just making, we keep an eye on women makers who persevere in markets that sideline their creative labors.

Here are three groups of mentors in my own creative life: marginalized artists who make beauty without the hope of reaching an audience, persecuted artists who keep making art imbued with truth despite the threat of imprisonment or even death, and elderly creatives who continue to generate beauty even as capacity and connections dwindle.

## Marginalized Makers

Tharu basket weavers are unseen artists—mentors without much hope of reaching the art markets but who persevere in creating. Let's travel to the eastern part of Rwanda to meet

a few more marginalized makers: women who are *imigongo* artists. Their decorative craft was almost extinguished during the genocide of the early 1990s, but a collective here and there persist.

A woman (and a few men, now that the art is starting to become profitable) starts with a wooden baseplate, which can range in size from a tiny photo frame to large-scale mural, used to design beautiful exterior walls of huts. The artist divides this plate into equal parts using banana fibers to ensure that the finished design is proportional. She then sketches geometric patterns—zigzags, spirals, diamonds, or squares—onto the plate with charcoal. The main material she uses is a mix of fresh cow dung and ash, which kills bacteria and odor. She turns this into a dough-like paste by hand and adds it to her design on the baseplate with her fingers. It takes about a day for the piece to air dry, and then she sands it for smoothness and covers it in a neutral base coat of ocher so that the four or fewer colors she adds next will be uniform in hue. Traditional colors include white from the clay mineral kaolin; red from the iron-rich Rwandan soil; yellow from ocher, another natural clay; and black from banana peel ashes, aloe sap, and poisonous soda apple fruit.

Take a look at this work online. Buy a piece and hold it in your hands. Gaze at the symmetry and elegance of the product. Reflect on the simplicity of the materials used and the ingenuity of the design. *Imigongo* artists' use of natural waste keeps us from the fallacy that we need state-of-the-art

tools, costly material, or cutting-edge technology to make jaw-dropping beauty. All that these women have needed for years are clay, fruit, sap, and dung. Oh, and also hands, fingers, creative minds, and artistic sensibilities.

Moving back to India, the land of my birth, I'd like to introduce you to another unheralded mentor of immense artistic vision: the sculptor Nek Chand Saini. I recently visited the American Embassy School in New Delhi, where my eye was drawn to sculptures that seemed to embody the least powerful workers of India. Despite or perhaps because of baskets on their heads or tools in their hands, their postures had dignity. Shoulders were down, spines were straight, and heads held high. The sculptures' expressions were resolute and stern.

When I asked my hosts about these, I discovered the magnificent perseverance of a self-taught Indian man who lived from 1924 until 2015. Mr. Chand wasn't a trained artist by trade. He worked as a road inspector for the public works department after Partition, but in his spare time, he collected material from demolition sites. Using shards of crockery and mosaic, broken glass and bangles, iron-foundry slag, concrete, and sand, he created hundreds of sculptures of dancers, workers, musicians, and animals.

Each piece, I learned, began with concrete poured over some form of metal skeleton, such as an old bicycle frame. Mr. Chand then carefully and painstakingly added small pieces of broken tile and other discarded, broken material to create a

mosaic of skin, hair, and textiles. The result was a figure about three feet high that was compelling, sturdy, and eye-catching. He then arranged them in pairs, trios, or groups that to me seemed like excellent company, balanced with form, size, posture, texture, and color.

But where might he display his products? Without worrying about anyone seeing his sculptures—in fact, hoping that nobody would—Mr. Chand arranged them illegally and secretly in a gorge designated as a land conservancy. He hid this sculpture garden of interlinked courtyards for eighteen years before it was discovered by the government in 1975. Today, a decade or more after his death, Mr. Chand's rock garden is a famous tourist attraction in India, second only to the Taj Mahal when it comes to numbers of visitors. The site also includes a doll museum, which displays two hundred dolls the artist made from waste cloth.

What a mentor! Nek Chand made neither for applause nor for admiration but only because he was compelled to bring order and beauty from chaos and ugliness. Again, divine work indeed. His sculptures and dolls, made with material discarded as trash, inspire us to keep making for our own delight and shalom even when our work is barred from reaching others. We might even create some products simply for the joy of making that are meant to stay secret and will never be for sale. Inspired by Mr. Chand, we consider this a tithe of our creativity, art made for two sets of eyes alone: our own and God's.

## Persecuted Artists

I also find mentors among artists who are or have been imprisoned or even killed by oppressors. In 1587, the Japanese Shogunate began a severe persecution of Christians, killing them or forcing them to flee the country. During that time, an unknown artist or perhaps two created a painting of immense power and significance. Now on display at Sawada Miki Kinenkan Museum in eastern Japan, the painting dates to the most intense period of this persecution. These artists, using black ink on a piece of *washi* (traditional Japanese paper), gathered courage to create fifteen scenes of events from the life of Jesus and Mary. (You can peruse this piece of art, created under such opposition, at a URL provided in the endnotes.)

As I gaze on this work, created in the harshest of circumstances, I let these artists who came before me fill me with fire to persist in creating. No matter how much I feel stymied by an inability to reach a wider audience with my work, and even in the face of *de facto* or *de jure* censorship, I can persevere in my devotion to my convictions and dedication to my craft, as they did.

At the same time, I continue to battle against the injustice of censoring any artistic expression. A pattern of being silenced can constrain our work. Sometimes, when I'm stuck in the middle of a story I'm writing for mostly North American children featuring characters with roots in marginalized cultures, an internal voice whispers that the market won't be

open to this kind of "niche" fiction. To keep pressing on and finish that story, I consider contemporaries like Rahile Dawut, a professor and guardian of traditional Uyghur folktales, who was recently named a PEN writer of courage. Dr. Dawut disappeared on the way to Beijing for a conference. Three years after her disappearance, her family and colleagues learned that Chinese authorities had imprisoned her for life on charges of promoting *splittism*, a term they wield to describe someone working against the interests of the communist government.

"She is being punished for being a hard-working scholar and for loving culture," her heartbroken daughter told the media. Dr. Dawut knew the risks. She knew that advocating for a threatened culture like the Uyghurs in a climate of persecution put her in danger. And yet she kept on with her beautiful work of curating and retelling traditional tales, as well as writing about Uyghur shrines of worship for pilgrims in that faith.

If I am being drawn to tell a story rooted in my own culture of origin—with marginalized Bengali women and girls as main characters—should I let the fear of a market that seems to cater to a more powerful mainstream deter me? Dr. Dawut and others like her didn't; neither must I.

## Creatives in Old Age

Finally, I take time to receive and contemplate the art of aging creatives. I look toward and learn from older people who keep

making in innovative ways even while losing capacity. Georgia O'Keeffe, for example, began making sculptures once she could no longer paint thanks to the loss of her eyesight at the age of eighty-five. My sisters recently treated me to a trip to Santa Fe, New Mexico, for a big birthday—a milestone that brings the fear of decline to mind more often than it used to. In a museum dedicated to O'Keeffe's creativity, I stood before her last oil painting, *The Beyond*, and took in the spirit of resignation and determination that emanated from it. It was dark blue on the bottom half with variegated strips of blue in different hues leading to the top, but about two-thirds of the way up, a strip of gleaming white drew my gaze forward even though the canvas was flat. Beyond the artist's failing eyesight, there was still light.

I also couldn't help noting that O'Keeffe was my age when she moved to Santa Fe from the East Coast. Now, after she created in New Mexico for thirty more years, the state claims her as their own, and the Georgia O'Keeffe Museum is a hub for aficionados of her art. *That could happen to me too*, I thought. *My best work could still be ahead. Take that, milestone birthday!*

Artist Virginia (Ginnie) Knepper Doyle, a lifelong painter and friend of mine, also began to lose her vision to macular degeneration a decade or so ago. She, like O'Keeffe, didn't give up on art but simply switched genres from more traditional landscapes and portraits to abstract expressionism. Now almost ninety-three years old, Ginnie is still in her

garden playing with color on canvas and producing stunning pieces of modern art that express deep emotions. I bought one of her pieces that resounds with color, energy, and light, and it hangs in our entry. Sometimes, when in a funk of worry about waning as an artist, I stand in front of it to simply breathe and contemplate it. Every time, it lifts my spirits and reminds me that I, too, can keep making with resilience and innovation as the years fly by.

Some believe that making art is the kind of work that improves with age. Noting that Claude Monet's series of brilliant Water Lilies paintings was trashed by critics in his time as the "work of an old man" with declining vision, Emily Urquhart writes this:

> *Renoir found new ways to hold his brush in the tight grip of his folded hands, and Monet saw through his cataracts—or maybe he painted from memory, or based on light—but, in the end, who better than an artist to innovate through struggle? . . . In an essay by Patricia Utermohlen on her late husband's final works, she wrote that William Utermohlen's self-portraits—arresting portrayals of his descent into dementia—were a way of addressing his fears and exploring his altered self, and that this necessitated a new form, new tools, even a new style. "The great talent remains," she wrote. "But the method changes."*

Perhaps talent and determination to create are enhanced by limits, like the flow of a river gathering force through narrow passages. The pinnacle of our capacity to create in youth is another lie, like the theories that we need resources, access to an audience, and even a government supportive of our art. All these myths are debunked as we contemplate the work of those who are or were marginalized, persecuted, and elderly. Their art takes the venom out of internal opponents who tell us we are too powerless or weak to create just art in a shalom-hungry world. Filled with hope that good work might still be ahead, we return again to a blank page or empty canvas.

## Just Abstract Art

*"My interest in art goes back to the first gifts I ever wanted for Christmas—paints and paper. When a desire to create begins in early childhood, one can rarely let go of it. During the past ninety or so years, my life has changed and I have shared my feelings about these changes through my artwork.*

*My paintings became more emotional as I progressively lost my eyesight. When I could see perfectly, I found it difficult to express exactly what my feelings were. But as I lost my sight it became easier to see what my emotions were by looking at my artwork.*

*Also, thanks to this loss of vision, I chose brighter colors with greater contrast to try to reach new ways to paint. Today, with an eye infection and nearly total blindness, I'm experimenting with painting over some of my photographs of scenes in the garden with oil pastels. The result is an even more abstract expressionistic style that is delighting me. In my ninth decade of life, with my eyesight more impaired than ever, I'm grateful that I can still paint."*

—*Virginia Knepper Doyle, expressionistic painter*

# 9

## LEAN INTO ANCIENT PRACTICES

A FEW YEARS ago, I found myself raging at the plight of Rohingya refugees fleeing Burma. *Someone needs to tell their story,* I thought. *I speak Bangla. I can understand their dialect. I should do it!* A story began forming in my imagination of an undocumented Rohingya child fleeing to Bangladesh. Yes, these refugees were Muslim, and I am a Christian who grew up in a Hindu family. But I'd already written one best-selling story featuring a Muslim protagonist, hadn't I? That book, *Rickshaw Girl,* had even been adapted, miraculously and marvelously, into a film by Bangladeshi creatives.

As I watched the movie version, however, I realized how good it was that Bangladeshi artists, instead of me, had taken the story from book to film. Deep in my gut, I took in how much their lived experience as Muslims had permeated their adaptation in subtle but important ways—nuances that were lacking in my novel.

I ended up writing a draft of a Rohingya story. But informed by this humbling experience, I then took time to retreat and ask myself questions about disordered attachments. Who would benefit from my telling of a Rohingya story: The

Rohingya? Or me? What happens when makers committed to justice are unaware of our own privilege? Will we err into appropriation and the pitfall of speaking for others?

As a result of this internal questioning, I returned from the retreat with a conviction to wait on my story and not try to publish it. A few days later, to my amazement, a Bangladeshi publisher asked if I could serve as a consultant on a picture book about Rohingya children in refugee camps. Bangladeshi and Rohingya aid workers with Save the Children would guide the story. They would be working from their broad knowledge base and deep experience with trauma-informed, culturally astute, boots-on-the-ground work with these children. I, then, was being asked to offer feedback on the narrative arc and word choices from a craft perspective. Recognizing an answer to my questions about appropriation and privilege, I let go of my own story fully and accepted the invitation. *The Unexpected Friend: A Rohingya Children's Story* was born.

Sometimes makers, especially those of us with more power, are invited to advocate for justice in a collaborative way that isn't about the individual artist and much more about the common good. What a beautiful opportunity! These days, when I recommend *The Unexpected Friend* widely to shine a light on the plight of Rohingya children, I am filled with gratitude as I remember the retreat that helped me gain restraint and discernment. Despite all the empathy, research, and imagination I try to cultivate in my process, I could never have

written this healing story for and about Rohingya children. As *School Library Journal* put it in a glowing review, "This beautiful offering has a lovely message of helping others, making it a solid choice for collections needing titles about social emotional learning or the plight of refugees."

Another outcome of this project, one that I might not have thought to orchestrate at the time is that all profits from the sale of this book are donated to Save the Children's Rohingya Relief Fund. Going forward, I'm trying to incorporate that into my artistic life, asking if any book I publish might include some profit sharing or donation to organizations that work to alleviate an injustice about which I'm writing.

## Disordered Attachments and Bad Habits

To create art that speaks of justice, we must be vigilant about discerning what is ours to do and what isn't, as well as what motivates us to create at any given moment. A longing for justice prompts us to create, yes, but our motives are complex and shifting. I've known artists with a rigorous focus on the practices we explored in chapters 6 and 7. Heck, I've been one. We gain mastery of craft, learn the rules of the market, build collegial relationships, and find third places. "I'm doing justice with my art!" we crow. For a while. But eventually, our once shiny product will get pushed to the side in favor of new, glittering art made by another.

Remember my second book, *Monsoon Summer*, that was thoroughly rejected but eventually released twelve years after my first novel? A few years after it was published, I was driving in my neighborhood and saw a sign in a school field: *Bake Sale for Orphanage in India*. Since my novel was partially set in an Indian orphanage, I decided I'd buy a brownie or two for this good cause. As I picked out my choices and a teenager plated them for me, I asked casually, "How did you guys get interested in this cause?"

She shrugged. "Oh, it was my friend's idea. She read this novel and got obsessed with doing this. We're all just along for the ride because we love her."

A novel? My interest, of course, was piqued. "A novel? Which one?"

"Let me ask my friend. Hey, what was that name of that book you read, like, ten times?"

A voice called back in answer. "*Monsoon Summer!*"

The title chimed out into the cold Boston air like church bells. Taking my plate of cookies, eyes blurred with tears, I stumbled back to my car. Here was proof that my art was actually doing justice. What a miracle. That moment was a career high.

Not long after that, I got the dreaded news from Random House: *Monsoon Summer* was going out of print. Sales weren't doing well, so they were remaindering the rest of the copies. (If you want to find out what this depressing publishing term means, look it up. Basically, in the age before e-books, it meant "your book is dead, darling.")

So that was that. Back to work, I guess, but how?

To persevere through years of a career with so much turbulence, I had to combat deadly opponents within my soul. We defined them in chapter 4: disordered attachments and vices or bad habits. These would have caused me to quit before my third book came out—*Rickshaw Girl*, my most successful novel, which to this day, to my delight, continues to reach readers. I share more about that book's publication origin story in chapter 10.

For now, let's unpack five ancient but powerful practices that have helped me combat bad habits and reorder attachments. I hope they might help you too. Again, I'll be drawing on Christianity as a source because it's my tradition, but the practices transcend any one religion, and I've also seen them serve nonreligious artists in their pursuit of just making.

## Practice #4: Welcome Moments of Mortification

Vainglory, as we defined earlier, is creating for the *primary* purpose of attention, approval, and applause. It prods us to produce art we think might be popular even if it means sacrificing our unique voice. It wheedles us into reneging on our creative calling: to promote justice by pursuing truth, beauty, and goodness in our art.

To detect and defeat vainglory, we can practice *welcoming moments of mortification*. These will come in any artist's

life, and they're hard to endure unless we claim them as invitations to purify intent and reorder attachments. So what are moments of mortification, and how do we welcome them? St. John Climacus defines the practice like this: "The Lord often humbles the vainglorious by causing some dishonor to befall them," he writes. "And indeed the first step in overcoming vainglory is to remain silent and to accept dishonor gladly. The middle stage is to restrain every act of vainglory while it is still in thought. The end—insofar as one may talk of an end to an abyss—is to be able to accept humiliation before others without actually feeling it."

I'm not good at any of these steps, but I'm trying. The first step when receiving dishonor—say, a bad review—is to stay silent. This means no ranting or raving on social media or in any circle that can bolster vainglory, which is insisting that we are entitled to applause, admiration, and approval. Remember our mentors from the margins who got no such reaction to their work? They will guide us into silence now.

Next, according to Climacus, we "accept dishonor gladly." We pay attention to our inner turmoil, where vainglory is still screeching out humiliation, and we discern the truth: "Aha! This is a 'moment of mortification'! I accept."

Now comes the second step—"restraining every act of vainglory while it is still in thought" so that our mind can be at peace again. In my own experience, this restraint on vainglory usually results from an action expressed by the body rather than with words. It mandates an *"act* of penitential courage,"

a phrase Father Timothy Gallagher uses to clarify the "acts of Penance" delineated in Rule Six ("Spiritual Desolation: A Time for Initiative") in Saint Ignatius's *Fourteen Rules of Spiritual Discernment.* This means that in mortification, it's difficult to *talk* ourselves back into a place of peace. The elimination of anxiety comes through the body *doing* something—a change in posture or placement in a space that typically requires bravery.

I haven't arrived at step 3 yet in this practice—"to accept humiliation before others without actually feeling it"—because I still *feel* humiliated every time. I can, however, share an example of the power of taking steps 1 and 2.

Back in the day, when the Indian immigrant community in the United States was small, I'd written several young adult novels with Indian American protagonists. They hadn't done well when it came to reception or sales. Now, fourteen years after my first novel featuring one such character, I'd published a new novel called *You Bring the Distant Near.* The market of Indian American teen readers had grown exponentially, and the book was getting applause with five-star reviews. It was even nominated for the National Book Award. *Finally,* I thought. *Maybe this is my big moment for a bestseller!* Vainglory purred approval with every good response to the novel. My publisher was sending me on tour; that vice was delighted, and so was I.

One of my stops was a book festival in Texas. It was a blazing-hot day, and we authors were positioned inside a tent to sign books. As I took my seat, I was smiling. I'd caught a glimpse of the massive horde of young Indian American

fans jostling outside, eager to enter the tent once the sign-
ing started. *Finally,* vainglory told me, *our moment in the sun.*
Meanwhile, the actual Texas sun was making the space inside
the tent feel like a sauna.

I found myself next to a younger Indian author who had
just released her first young adult novel. I took my seat—and
my role as her mentor. *How might I serve and encourage this
first-timer?* I found myself thinking. Was that generosity—or
was it vainglory, disordering my attachments again?

It wouldn't take long to find out. The tent flaps opened,
a stream of Indian American girls poured in . . . and took their
places in line before the newbie author. Not *one* was standing
in front of me.

I was mortified. Humiliated publicly. My publicist stood
behind me, and I could feel the stress emanating from her.

I stayed seated, even though vainglory raged at me to
storm out of the tent immediately. By this point in my life as
a writer, I'd spent time with Saint Ignatius's rules in retreat. I
glanced over at my neighbor; she was "doing the needful," as
they say in Indian English—smiling, bantering with readers,
and sweating profusely. Then I glanced down at the brochure
that I'd been handed—a large, laminated placard delineating
the festival's schedule.

*Dang,* I thought. *Acts of penitential courage.* I knew what
I had to do.

Standing up, I took the placard and moved behind my
neighbor. Slowly, I began to fan her. She turned to see what

was going on, gave me a sweet smile, and then lifted her long black hair so that the breeze I was creating could reach her hot neck.

Instantly, gratitude flooded my mind and heart. I could feel the joyous reordering of attachments in my heart as the Augustinian priorities I described above fell into their right order. The lack of reception still rankled, but I could feel vainglory releasing me from an inner torment of anxiety and frustration.

I'm grateful for that moment and for a tangible act of penitential courage that came to mind as a way to combat vainglory. After the event, the newbie author and I became vocational friends. I've been able to encourage her authentically through the ups and downs of the career. Before my humiliation, I had "nobly" aspired to do so, but I had done it from an internal position of superiority.

My young publicist started following me on social media after that tour, sharing her life and dreams, and we're in touch even though that she's moved on to another career. And while *You Bring the Distant Near* never became a *New York Times* bestseller, I still receive notes from young Indian American women who tell me my novel made them feel seen with a loving gaze. I've reclaimed the truth that I'm proud of my own work, no matter what kind of response it gets.

I invite you to join me in this practice of recognizing and embracing moments of mortification. Pay attention to hot cheeks, anxiety, and a compulsion to fight, flee, freeze, or

faint. I can almost guarantee that an act of penitential cour-
age will be made clear if you recognize the turmoil provoked
inside by vainglory and ask for guidance to combat it. If we
resist vainglory with courageous actions, shalom and flourish-
ing can be the results in the long arc of a creative life.

## Practice #5: Fast to Embrace Vulnerability

As I write this, I'm nearing the end of a long stretch during
which I gave up social media for Lent. All year long, I have
guards in place to calm this insatiable digital beast: my noti-
fications are turned off, I don't bring screens or phones into
the bedroom during sleep, and I usually take Sundays off from
the internet. But now I've been fasting from social media for
forty days in a row. What I've discovered about my interior life
over the past few weeks is challenging to face. The habits of
social media—which, for me, involved several hours a day of
responding to others' posts, commenting, reading comments,
viewing reels and other content, promoting my work and
events, and creating "clever" content to elicit interaction—
had become a way to avoid feeling pain. In other words, I
had fallen prey to gluttony. As a final blow, I could see that
indulging in this habit to numb my emotions was affecting
my writing.

I can confess that after this long fast from social media,
my psyche is reeling. When you fast from something to which
you've become so attached, you must confront the range and

depth of emotions that have been festering inside and from which you have been distracting yourself.

Sometimes it's brutal to feel our feelings. But we must, especially to create the kind of work that serves our neighbor justly. "Great art comes from great pain," claimed Christopher Zara, author of *Tortured Artists*, a collection of forty-eight profiles on some of the most celebrated artists of the millennium—from Mozart to Woolf, Garland to Disney. "Art produced without suffering is not likely to be very good."

I don't entirely disagree. But is pain the only emotion that informs meaningful art? I like poet and essayist Victoria Ford's response to Zara's claim. Suffering is one way to create meaningful art, but Ford suggests it's not solely pain but a wider vulnerability to emotions that makes us human. She calls us to enter into the full range of our humanity as we create art. "To discover something from a moment of joy, fear, shock, rage, empathy, appreciation, jealousy, epiphany, or suffering is to become an artist," she writes. "Great art comes only from those willing to be vulnerable."

"The people who wade into discomfort and vulnerability and tell the truth about their stories are the real badasses in this world," writes sociologist Brené Brown. Such vulnerability demands bravery; everyone is tempted to use habits or substances to avoid it. The challenging practice for artists who want to express a range of emotions—that is, who want to practice badassery—in our art is to practice periodic fasts from these numbing agents. (There's an exception, of course,

to this practice of fasting. Again, I'm not suggesting taking a hiatus from prescribed drugs that stabilize and restore mental health and keep us breathing and creating.)

What, then, does this practice of fasting look like for an artist? First, identify any numbing agent or habit that is keeping you from "discomfort and vulnerability" and bring it into the light. I recommend telling one or two trusted friends that you're about to detox. Next, set up a rhythm of fasting from that habit or substance that works for you. This could mean one day each week, a few hours every day, some or many days in a row, and so on. Shape a fasting practice that's challenging enough to allow emotions to emerge and yet not be devastating or overwhelming to your soul. Loving self is an important guide here; if you need and can afford it, good therapy is useful.

Third, confront emotions by journaling and expressing them to safe people, including counselors, friends, partners, or in confession. Once you know what you're feeling and why, is there a way to incorporate those emotions into your art so others benefit? "So ensure that this ache wasn't endured in vain," wrote the poet Amanda Gorman. "Give it Purpose. Use it."

## Practice #6: Pursue Community to Counter Envy

Envy is a wild beast. In *The Canterbury Tales*, Chaucer's Parson says that it is the worst of sins, "for in truth, all other sins are at times directed against one special virtue alone. But envy takes

sorrow in all the blessings of his neighbor." Envy, unlike the other vices, steals our inward joy and peace and makes us sour and disgruntled over other artists' wins. This inner pettiness is sure to harm our making. How might we tame this vicious vice? The best practice is to pursue creativity in community.

Modern-day artmaking is lonely work, making us even more susceptible to envy. Envy divides us and operates out of a scarcity mentality. It tells us that another person's "win" becomes my "loss." What can we share with our so-called competitors to shift our mindset from win-loss scarcity thinking to a win-win situation of abundance?

First, we invest in a practice discussed earlier: *collaborating* with other creatives. Even work that we think is wholly ours is a community effort. I started my writing career with novels penned exclusively by me—or so I thought. What I've come to see is that fiction I've enjoyed in the past, writers I admire, teachers, editors, agents, and even readers all contributed significantly to my stories. Can I really claim the work as "mine"? I've also written picture books, where collaboration with illustrators makes the book "ours." In traditional publishing, this product is the result of a joyful partnership between two makers, negotiated by an editor and art director. I'm always delighted and thankful for what a visual artist contributes to a picture book that bears both of our names.

Next, we affirm our common *mission* as artists to bring flourishing and healing to a world of brokenness and pain through our art. As we reconnect with this broader calling,

when one of us wins by reaching many people with a product that resonates with truth, beauty, and goodness, all of us do, right? Pushing back, envy will mutter to wounded pride: "It wasn't as true, beautiful, and good as *your* product . . . so why did *it* get the win?" Or maybe envy says, "You'll never be as good of an artist as that person, so you might as well give up now." Here's where we respond with words that both honor and surrender our own art: "I know you're flawed, but I see a glimpse of truth, beauty, and goodness in you. You will reach the right recipient at the right time in the right way." Surrendering the things we make involves recognizing the mystery of a dialectical relationship. Making meaning around art is a shared response between a creator and a recipient, and we have no control over the latter.

This leads to a third way to tame envy as soon as we sense it lurking in the corners of our souls: through setting an intention of *gratitude for all creativity*. We hunt for beauty, truth, and goodness produced by other human beings on a daily basis, both on big stages and in unseen places. We celebrate it in any shape or form, unfettered by the extent of a person's natural talent. While it is right to battle against inequality of access to express talent, we must accept the reality of inequality in the level of talent across all humanity instead of bemoaning our own lack in comparison with someone with a greater store.

Cultivating this habit of gratitude for creativity by all kinds of artists, including ourselves, expands our souls, which, in turn, can lead us to more beautiful, true, and good making.

In an article titled "What Dante Can Teach Us about Envy," translator Anthony Esolen writes that "the magnanimous soul embraces the good of his neighbor as if it were his own, and deplores his harm, likewise. It does so, not by some egotistic appropriation of the good, but by a joyful and large-hearted recognition of inequality." As we give thanks for the free and varied talent expressed by geniuses, fools, children, those who are marginalized, and others, including ourselves, we silence the insidious and creativity-killing voice of envy.

## Practice #7: Retreat to Let Anger Breathe

Anger, as we discussed earlier, can lead to the creation of magnificent art as it confronts injustice, expresses lament, inspires revolution, and inspires change with a prophetic voice. When furious over injustice in personal, communal, or political venues, we yearn to make art to combat it. Yet if we let this emotion run amok without examination, anger can damage ourselves, our work, and others instead of igniting the kind of making that results in shalom.

Before we send any anger-generated product into the wild, a good practice to counter this vice's desire to control is to retreat into solitude and silence. The more privilege and access the world gives our voice, the more vital is this practice. Remember my ill-conceived idea of writing a Rohingya story—on my own—from the beginning of the chapter? My idea grew out of righteous, well-placed anger at the plight of

refugees, but I'm still glad I wasn't led by my anger. A retreat is what saved me from pursuing publication of my own story and enabled me to choose collaboration with other creators.

A brief or extended retreat, for the purpose of self-examination, can be most effective *after* we've first attempted to create art while in the throes of anger. A first try invites unbridled anger to be part of the process. But then we put down the product to give it air and space.

For silence, we distance ourselves from screens and plugs that are avenues for noise, both our own and the clamor of outside voices. We back away from others and gaze inward, assessing the anger driving us. In solitude, we journal about the injustice that provoked anger and reflect on the emotion simmering inside us.

Here are some questions to explore anger as we retreat. Am I angry on my own behalf? Am I angry on behalf of others? If so, can I confess my hatred and desire for vengeance and punishment for the perpetrators during this time of retreat? How might I see my anger as justified but not allow it to violate my own or another's freedom and dignity? How might I prevent my anger from corrupting my art with lies instead of truth, evil instead of good, ugliness instead of beauty?

Paulo Freire, a Catholic scholar and community organizer, wrote *Pedagogy of the Oppressed*, a treatise on pursuing freedom and change using a cyclical process of action and reflection. "Because it is a distortion of being more fully human, sooner or later being less human leads the oppressed

to struggle against those who made them so," he claims. "In order for this struggle to have meaning, the oppressed must not, in seeking to regain their humanity (which is a way to create it), become in turn oppressors of the oppressors, but rather restorers of the humanity of both."

In this claim—that our resistance to injustice must humanize both the oppressed and the oppressor—Freire is echoing the philosophies of Mahatma Gandhi and Martin Luther King Jr. Sometimes, though, the offense feels so egregious and the oppressor so evil that we want to channel a more violent revolutionary power. Even so, a retreat for reflection and self-examination is crucial as we don't want to become like the pigs George Orwell wrote about in *Animal Farm*: overthrowing oppressors only to become oppressors ourselves, as Freire put it.

Am I angry on behalf of another person or a group of people suffering injustice? If so, voices in my head might be telling me that *I* must create to express their pain: "This is an outrage! Nobody else can advocate better for these people than *I* can! My anger on their behalf *must* be expressed through my art!" Does this kind of reasoning hint at the presence of pride? Might this be a call to "wait to create" or to encourage creative expression by those unseen and voiceless instead of insisting on making our signature art on their behalf? If it's difficult to let go of a particular project, it's worth asking why. Reflecting on flaws in our past work when it comes to questions of appropriation, privilege, and power is a difficult but

important task, one that serves us well in the long journey of a vocation rooted in justice.

The next question to investigate on a retreat into solitude and silence is this: has my anger morphed into wrath—an expression of anger that seeks to control? The truth is that good art is rarely made with this intention. "Our bad anger thus shows us to be trying—and failing—to be God," Rebecca Konyndyk DeYoung writes about wrath. "We are wrathful when we can't control things that hurt us and keep them at bay. Our anger is ready to remedy this vulnerability by taking control of establishing justice in the world and avenging any wrongs. . . . Wrath's expression therefore usually involves the assertion of control."

The unexplored vice of wrath that seeks control in or through the process of creativity can have negative consequences. First, it tempts us to a hurry that can cause us to plagiarize subconsciously instead of creating with fresh truth. "In art there are only two types of people," wrote the artist Paul Gauguin. "Revolutionaries and plagiarists."

Second, wrath tempts us to make propaganda instead of art. If I write fiction primarily to control or convince my readers to adopt a belief or position, for example, that agenda commandeers the process of my making. Even a young reader can sense a writer's effort to manipulate or control their thoughts. We must leave room in art for the recipient to *think, feel, and respond in freedom* instead of shaping our art to tell them imperatively how to think, feel, and respond.

Third, unexplored anger can, put simply, result in shoddy art. When we're using it primarily to trigger emotions like anger, sadness, patriotism, or nostalgia in the recipient, we create shallow, sentimental products that others easily classify as kitsch.

After asking questions like these during a retreat in solitude and silence, we meet our art again with a cooler head. Now we recognize more clearly if we're letting pride or vengeance drive us; whether we've veered into control and edged into plagiarism, propaganda, or simply trite or shallow work.

A next step, then, could be to put away the project for now and let it wait even longer. If or when we do feel freedom to proceed, we then revise or reshape the product from a place of confidence, conviction, and courage instead of wrath. We weave into both process and product a freedom and dignity that welcome a free and vulnerable response from the recipients of our art.

## Practice #8: Create Rhythms of Rest and Work

The last vice, sloth, leads us back to the original groundwork we laid in part 1 of this book. We work because we love God, self, and neighbor. That's why sloth tries to hinder any artist pursuing a long journey of faithfulness: it seeks to crush love. Sloth tempts us to seek restless diversion or entertainment

instead of making, reminds us that the process is dull and tedious, and tells us our products aren't worth the effort. Sloth ensnares us, via procrastination, into a cycle of debilitating self-hatred because we aren't making.

The practice to defeat sloth is simple: To love God, neighbor, self, we make creativity a habit. We spend some time regularly working on our art. "Put your butt in a chair every day!" is the pithy command issued by prolific children's book writer Jane Yolen, and she often offers "BIC" as an acronym when she speaks to younger writers. To attain this kind of daily rhythm, recent popular and practical advice on habits comes in handy. Habit guru James Clear, author of the best-selling book *Atomic Habits*, tells us to form a habit by aligning it with four laws of behavior change, that is, making art as part of our daily routine should be *obvious, attractive, easy,* and *satisfying.* Here are a few tips, based in the work of James Clear, to put these laws into practice.

Start small: try to do your art for ten to fifteen minutes a day, enough to get in the flow.

Stack habits: say to yourself, "After I do [a current habit], I will create art."

Since making art has a delayed reward, add an immediate reward after the habit: brew and enjoy a fresh cup of coffee, for example, or treat yourself to a stroll around the block.

Make habit success easy—for example, leave your easel or computer accessible and ready for work—and make habit

failure harder—turn off notifications and/or Wi-Fi connections, turn large screens around to face the wall, employ airplane mode, or delete distracting social media apps from your phone.

Track your habits to encourage progress: there's an app for that in your line of work, I'm sure—but don't let it divert you!

Find people who are also forming the habit of making. I've met friends in coffee shops to write in silence together for a couple of hours; other writers arrange virtual meetings, during which their heads on one another's screens aren't interacting but engaged in solo creative work.

In my effort to make daily writing a habit, I've read countless how-to articles and books. Sadly, reading about habits can easily become yet another restless diversion I use to avoid writing. I'll leave researching other tips and hacks on forming your habit of making up to you!

In any case, the gift of one day of rest in a seven-day week is helpful. For six days each week, we show up for our art one way or another. At the end of the sixth day, emulating the Creator in the book of Genesis, we consider the goodness of our work and then rest for a full day.

Neuroscience agrees that a day of cognitive rest can enhance creativity. Research shows that taking a daily break once a week sends our brains into a default mode network (DMN), during which it is sorting through memories and experiences and making deep connections on a subconscious

level. When we return to work after a day of resting our brains, new ideas can rise up from the DMN into our conscious brain, and thus infuse our making with renewed zest and purpose.

Unleashing the creative power of our subconscious mind with rest means avoiding diversions of "watch next episode" entertainment streams, shopping as a time-wasting activity, unrestricted scrolling on social media, clicking from story to story full of ads as we try to process disturbing current events, or any other self-indulgent and mind-numbing activity. It's best if this day of rest for the brain can include embodied activities like taking a walk, shower, or short nap; playing a sport; engaging in spiritual activities like singing or listening to music; reciting liturgy in community; rereading a classic book from childhood; and praying or meditating. I try to take a full day off from screens and plugs on Sundays; I invite you to join me in this life-giving practice of Sabbath rest to combat sloth.

Well, there you have it—five practices from days of yore to help us keep making: welcome moments of mortification, fast to embrace vulnerability, pursue community to counter envy, retreat to let anger breathe, and create rhythms of rest and work. If these seem challenging, wait for the next two! But I can promise that all ten practices we explore will help us persevere in the making of art while doing justice. I encourage you to experiment with them using the reflection and discussion questions included at the back of the book.

# Just Singing

*"Singing is about body coordination and is more akin to catching or throwing a ball than to painting a picture or writing a novel. When my body is correctly organized with the intention that harmonizes with the function of my body (lower body releasing down into the floor, my upper body releasing forward and up), I have minimal amount of unnecessary tension in my body and can release my voice. There is so much to be said about 'everything in its right place' of the body. It takes years to discover, and even then there's no mastery—just more discoveries. The voice emerges from the body and reflects the body that releases it; an open body will release the fullest, most resonant sound. Because of this, I describe singing to my students as 'radical openness.'*

*In singing, when this is modeled for the audience in performance, the audience receives the voice into its nervous system, and the singer's body map physically changes the audience. This is why we are inherently moved by those singers whose bodies are 'justified' (organized). The perception of the audience is that the singer produces a moving sound— physiologically, this is due to the nervous systems of the singer, modeled in the voice uniting with the audience across the room. The singer acts like a host of*

*a dinner party, leading the conversation, using their talent and ability—not for themselves but for the service of the audience and their nervous systems.*

*What surprises me about this is how much internal work it takes before you can even begin to externally address others. It's the job of the artist to look inside, correctly organize the body, find one's voice, and then release it for the audience. The song sings my body as much as the body sings the song— echoing from my toes to my eyelashes."*

*—Chad Somers, opera singer*

## 10

# CROSS BORDERS AND
# LIBERATE THE WORK

HOPEFULLY BY NOW, I've convinced you that making art can bring justice to the artist, the receiver, and the community. Maybe you've learned some strategies for dealing with a tough market and destructive internal forces. I want us to see that by restoring agency, finding third places, and seeking mentors in the margins, we can keep making justice-filled art and that by leaning into ancient practices, we find freedom from bad habits and disordered attachments.

But there are still some interactions between the two vocations that can degrade art making, on the one hand, or doing justice, on the other. What about mistakes we artists make and the resulting pain we cause? What if, despite our best intentions, we bring not only beauty into the world but also injustice?

Here are a few such errors. Prejudices and mores stemming from a particular culture, subculture, or era inevitably shape an artist's heart. More consciously, we can rush to make a product out of a desire to do justice, as I was about to do in the throes of passion over the plight of the Rohingya refugees. Such headlong creating results in an unexamined process at best and appropriation at worst, as we discussed earlier. A

related clash between making art and doing justice we've also considered is that, thanks to the artist's compulsion to make a statement of some kind, the work itself can end up seeming didactic, rigid, and heavy-handed or marked by sentimentality and mediocrity.

The means cannot justify the ends if we end up dehumanizing others, compromising our own dignity, or damaging the integrity and quality of our art. The practices we've already explored can restrain some of these errors. Let's look at two more that can keep them in check: crossing borders and liberating the work.

## Practice #9: Cross Borders with the Body

Writing fiction involves crossing a border of power, which is perhaps why the errors of appropriation and prejudice often show up glaringly in novels. Words can be dangerous tools. Stories are powerful agents of change but can unwittingly serve powerful interests in ways we don't intend. Maybe that's why the flaws in art made by an author, poet, or lyricist might be easier to spot than the flaws in art made by painters, sculptors, composers, quilters, or other artists. Visual art, on the other hand, can sometimes become more about presenting a wordy message in camouflage than serving as a vessel of beauty, truth, mystery, or goodness.

In my book *Steeped in Stories*, I shared a few questions I ask myself before crossing any border of privilege between

my main character and me. The wider the gap of power, the more important it is to slow the process of making and examine intentions and motivations. Another consideration is the power gap between my intended audience and me. For example, writers of fiction for children—who are vulnerable human beings in formation—must take into account that the power differential between creator and recipient is wide. In such cases, we tread even more carefully so that we don't perpetrate violations of justice against young people.

Self-examination is vital, as we covered in our discussion about the five ancient practices. But what we do with our bodies in real life is perhaps even more valuable. "If you're going to cross a border of power in your writing, cross it first with your body," I once heard someone counsel young authors. "Then, stay there for a long time, shut up, and hold a bunch of babies."

I like that advice. It led me to take stock of where my body travels in real time in my desire to do justice. Do I have mutual relationships of trust and caring with people who are different from me culturally and socially? When did I last listen intently to and learn from someone with significantly less money or education than I have? What about with people who are double or half my age: have we broken bread together or lifted a cup? Have I shared laughter, hospitality, stories, songs, and tears, in an equal give and take, with people who are different from me? I'm encouraging us to seek real-time, face-to-face interactions, not digital ones. Where our bodies

breathe, our minds and souls follow. That's how we're formed and informed. Eventually, so is our art.

Donating money to good causes, serving in shelters or soup kitchens, marching in protests, building homes for the economically disenfranchised, traveling overseas to feed those who are hungry or sink a well for clean water, and other good works are important acts of justice; I don't demean them. But to truly shape our souls—the deep well from which we consciously and subconsciously draw to create our art—the real questions we must ask are about love. Are we crossing borders in our lives and in our art out of some ulterior motive, even a good one? Or are we crossing borders out of love?

## Practice #10: Liberate the Work

One of the great mysteries of this vocation is that the art itself, along with the creator and the receiver of it, must have a voice in the making. To provide the dignity and freedom our products need to flourish, we don't start by interrogating ourselves or the work with questions about themes, values, morals, meanings, or messages. We simply let craft and material lead the way. For me, that includes characters, settings, structures, and words; for you, it might mean brush, canvas, and paint or whichever nuts and bolts might be in your genre's toolbox. We relinquish our need for control and start making.

Given that our subconscious minds are shaped by bodies doing justice in the real world, can we let go of control

and create without any conscious agenda commandeering or overpowering the product? This question applies equally to compassionate creatives and religiously or ideologically compelled makers who long to express convictions in art. In the long run, will releasing these agendas before and while we make result in better and more just art that stands the test of time?

I believe so.

One of my role models in writing literature for young people is Madeleine L'Engle, author of the acclaimed *A Wrinkle in Time* and other books. She writes this in her indispensable book *Walking on Water: Reflections on Faith and Art*: "It is a joy to be allowed to be the servant of the work. And it is a humbling and exciting thing to know that my work knows more than I do."

L'Engle goes on to compare the artist with a pregnant woman who receives and nurtures something completely apart from herself but still residing within her. She suggests this is what Mary did when the angel appeared to her nine months before the birth of Jesus. "Each work of art, whether it is a work of great genius, or something very small, comes to the artist and says, 'Here I am. Enflesh me. Give birth to me,'" she writes. "And the artist either says, 'My soul doth magnify the Lord,' and willingly becomes the bearer of the work, or refuses; but the obedient response is not necessarily a conscious one, and not everyone has the humble, courageous obedience of Mary."

Greater writers and artists than I, with more intelligent philosophical and critical minds, have debated the necessity of freeing art from political and religious agendas of the day. Defenders of such liberty include Leo Tolstoy, T. S. Eliot, Flannery O'Connor, W. H. Auden, C. S. Lewis, and my beloved Madeleine L'Engle, among others. Critic Jed Perl sums up their views in the closing paragraph of his book *Authority and Freedom: A Defense of the Arts*: "But the decision to reject doing in favor of making, which some have described as a retreat into self-absorption and narcissism, is in fact an act of courage. Artists reenter the world by sending the work that they've made back into the world, where it lives on—independent, inviolable—in what Auden called 'the valley of its making.' That is a place apart—paradoxically, triumphantly apart."

Of course, the artist's beliefs, passions, intents, and motivations still play a role. They must; art, as we've said, is created in a dance of mystery between an individual and the product. Artificial intelligence might imitate and even simulate products that are pleasing to the eye, but it can't join this dance. The kind of art that offers shalom depends on a human artist with a unique voice, lived history, and a particular combination of identities: a living, breathing person who is submitting humbly to the authority and tradition of craft and community, seeking to serve and love, experiencing pain and suffering, making and learning from mistakes, and expressing freedom despite constraints.

Relying on L'Engle's analogy, we can see that the process of just making, like childbirth, is messy and painful. Our creative work may end up more nuanced than passionate people on any side of any political or religious spectrum deem acceptable. Our art will be misunderstood and maligned, even by critics who ostensibly share our beliefs. Are we ready for this? I am, and I hope you are too.

## Full Circle

One evening many years ago, I was at another mortifying "signing" for a novel. I enclose that word in quotation marks on purpose: there were zero visitors at my table and queues snaking the floor for authors flanking me. It was for my second novel, *Monsoon Summer.* I was tempted to depart the scene. Why stick around if no one wanted me to sign their book?

But I was a mother with young children, and time to work on revisions to my third novel was in short supply. So instead of fleeing, I pulled out the pages of my manuscript for *Rickshaw Girl* and got to work right there at my empty signing table.

This book had already been rejected many times, but I cared about it deeply, and I couldn't stop thinking about it and tinkering with it. In the story, I delved into the justice of microcredit—small low-interest loans provided to women makers. I wrote about the talents of Bangladeshi women like my great-grandmothers, who painted traditional *alpana*

patterns with rice powder paint on doorsteps and stitched quilts as they chatted about village happenings. I was writing about duty to family and about honoring elders, values that resonated in my culture of origin. But at the time, the market didn't want a story set in a "foreign" place with no Western characters. My book had a Muslim hero, no less—and this wasn't long after 9/11.

Still, despite the closed doors, I couldn't bring myself to let go of the story. So right there at the "signing," I took my pen and began the work I knew so well: putting in one word, taking out another. Soon I forgot all about my humiliation in the joy of flow.

My writing was interrupted by a woman who left her spot in another author's line. She came over to ask what I was scribbling with my red pen. I told her about the heroine, Naima, an unheralded artist, and about her quest to help her family financially in a culture where the economic power of girls was limited. We chatted, and it turns out my visitor was an editor at a publishing house, Charlesbridge, which focuses on books for children and young readers. She asked to see my story and gave me her contact information. I sent *Rickshaw Girl* to her, and they bought it.

After the novel was published, it won no awards and got no starred reviews. But slowly, over the years, it gained traction among readers. First, it was translated into several languages, mostly Asian. Next, it was adapted into a stage play by the Bay Area Children's Theater.

And then, fifteen or so years after the novel came out, a cinematic version of my story premiered. Spearheaded by the brilliant Bangladeshi director Amitabh Reza Chowdhury, the film narrated a hero's journey about a young female artist loosely based on the girl in my novel. I gussied myself up for the red-carpet event, knowing this was a once-in-a-lifetime moment for a writer like me. Heck, for any writer. This called for my fanciest *shalwar khameez*, my reddest lipstick, and the highest heels I could manage without breaking an ankle.

As I sat in the theater, watching the film based on my story, the realization of a full-circle moment struck like the proverbial bolt from above. Through the gift of collaborative creativity, mine and the filmmaker's, a descendant of Hindus—ancestors who had feared and hated Muslims for generations—was offering just art with Muslim descendants of those who had warred with my ancestors. *Blessed are the peacemakers*, I thought and felt deeply grateful for both the story that I had birthed and the makers who brought it to the screen.

After the premiere, the circle of shared creativity deepened and intensified. The director of *Rickshaw Girl* handed me a gift: a gorgeous *nakshi kantha* quilt from a village in Bengal. Squares of cloth in jewel colors and intricate patterns were matched in a design that somehow dazzled and soothed the eye simultaneously. Stitched by unknown brown female hands akin to those of my great-grandmother's, that quilt is one of my most cherished possessions. If you ever visit me in

person, I'll show it to you. Otherwise, feel free to picture me dreaming up my next novel as I snuggle under this work of art on a chilly night; I've posted a picture of it over at justmakingguide.com.

Whenever I touch and look at it, I think of a quilt of makers, around the world and throughout history, a pattern that you and I join when we put pen to paper, needle to fabric, brush to canvas, or voice to song. We are not alone in our artistic journey to spread shalom in a suffering world. Those stitches remind me of the great community with whom we are connected in this joyous vocation: the work of making, justly.

## Just Make It!

Thank you for accompanying me through this book, friends. Let me summarize the ten practices that can help us keep making in the face of external and internal resistance:

Practice #1: Restore agency in the vocation.

Practice #2: Find third places.

Practice #3: Seek mentors in the margins.

Practice #4: Welcome moments of mortification.

Practice #5: Fast to embrace vulnerability.

Practice #6: Pursue community to counter envy.

Practice #7: Retreat to let anger breathe.

Practice #8: Create rhythms of rest and work.

Practice #9: Cross borders with the body.
Practice #10: Liberate the work.

I've provided reflection and discussion questions that can help you discuss these practices either on your own with a journal or in a group of makers. The latter venue, in my opinion, is a slightly better one. Sharing insights and practices with others is an excellent way to keep making in pursuit of shalom for ourselves, one another, our communities, and the wider world.

I'd like to hear more about your work and practices to keep making. Join me at justmakinguide.com to share your stories, products, resources, practices, and other insights. Please consider that site a third place; I will strive to make it safe and welcoming for anyone who enters.

In your efforts to do justice, I invite you to keep making art permeated with beauty, goodness, and truth. I'm eager to receive it for the transformation of my own life, and so is a world in need of healing and justice. Ultimately, we can theorize and ruminate and talk as much as we want—and we've done a lot of that in this book. But when it comes down to it, we pick up a brush or face the keyboard or wield the particular instrument needed for our work. Maybe we employ only fingers and hands, as we saw with some of our makers in the margins. In the end, the work of creativity and justice all hinges on a verb. When it comes right down to it, we *just make it*!

# REFLECTION AND DISCUSSION QUESTIONS

## Part I: Creativity and the Just Life

1. How does making art bring shalom into your life?
2. Describe a song, novel, or piece of art that has stirred your soul recently. How did it resonate with beauty, truth, and hope?
3. How can art make the world a more just place? You may want to think in terms of the artist, a receiver, and the community.

## Part II: Why We Stop Making

1. What is your relationship to the market like at this moment in your life? What conversations have you had with other creatives about how to reach audiences with your work?
2. How does despair over world or personal events affect your creativity?
3. Which vice or bad habit described in the book is the biggest struggle at this point in your vocation (vainglory, gluttony, envy, anger, sloth)?

# Part III: How to Keep Making

### Practice #1: Restore agency in the vocation

1. What steps can you take to hone craft, master rules, and build collegial relationships?

### Practice #2: Find third places

2. Which kind of third place suits you better — digital or local?
3. Create a list of possible venues to host your work and share a plan of action to approach them.

### Practice #3: Seek mentors in the margins

4. How have marginalized, persecuted, or elderly makers inspired you and fueled your energy to keep making?
5. Choose a piece of art made in the margins. Hold it in your hands, if possible, and take it in silently with the senses of touch, smell, and sight. What do you like about it? How was it made and by whom? Do you know or can you discover the journey the product took from maker to you? Who profited financially and how?

### Practice #4: Welcome moments of mortification

6. Have you endured a high-anxiety moment like the one I describe in which no one came to my signing table?

7. Was there an act of penitential courage your body took or might have taken?

### Practice #5: *Fast to embrace vulnerability*

8. Identify any numbing agent that is keeping you from discomfort and vulnerability. Consider it for a moment, thus bringing it into the light.
9. What effect does using this numbing agent have on your art?
10. Are you willing to try to detox from it? If so, tell one or two trusted friends that you're about to start a fast.
11. What feelings come up during that fast?
12. After caring for yourself in healthy ways, is there a way to incorporate those emotions into your art so others benefit?

### Practice #6: *Pursue community to counter envy*

13. Whom do you see as your competitors?
14. Are there ways to support and celebrate their work to shift from a scarcity mindset to a win-win situation of abundance?
15. Frame a sentence or two of gratitude for each "competitor's" talent.

### Practice #7: Retreat to let anger breathe

16. Are you angry on your own behalf? Are you angry on behalf of others?

17. How might you acknowledge that your anger is justified without allowing it to violate your own or another's freedom and dignity?

18. How might you prevent anger from corrupting your art with lies instead of truth, evil instead of good, ugliness instead of beauty?

19. What injustices in the world make you angry? How might you use that anger as fuel for just making without letting it consume you or overpower your art?

### Practice #8: Create rhythms of rest and work

20. Describe a few of your habits of making. Set a goal to change them using one or more of James Clear's tips.

21. Do you create in the company of others? Does this help or hinder your work?

22. Do you take a day of rest in a week of making? Why or why not?

### Practice #9: Cross borders with the body

23. Do you have mutual relationships of trust and caring with people who are different from you culturally and socially? If so, describe one such friendship.

24. When did you last listen intently to and learn from someone with significantly less money or education than you have? What about with people who are double or half your age?
25. If you come up empty in response to these questions, consider how you might begin crossing a border— with love. Which opportunities for genuine relationships across borders exist in your community?

### *Practice #10: Liberate the work*

26. Define and name three convictions or ideologies that are dear to you.
27. How do these affect your work?
28. How might you release these agendas for the sake of the work?
29. Does letting go make you excited or uneasy about your process? Journal or tell your friends more about this reaction.

# NOTES

## Introduction

1    ***Time speeds by:*** "The Casual Observer," *The Daily Graphic*, May 8, 1884, https://www.oscarwildeinamerica .org/quotations/took-out-a-comma.html.

2    ***I wrote this book as a guide:*** Friedrich Nietzsche, ed., "Chapter 5: The Natural History of Morals," in *Beyond Good and Evil: Prelude to a Philosophy of the Future* (Leipzig: C. G. Nauman, 1886), https://gutenberg.org /cache/epub/4363/pg4363-images.html.

3    ***I also saw the way that some stories:*** "The Danger of a Single Story," Chimamanda Ngozi Adichie, TEDGlobal, July 2009, https://www.ted.com/talks/chimamanda_ngozi _adichie_the_danger_of_a_single_story.

7    ***"The place God calls [me] to":*** Frederick Buechner, *Wishful Thinking: A Seeker's ABC*, expanded ed. (New York: HarperOne, 1993), 118–19.

7    ***"I have come to believe that unless we are making":*** Makoto Fujimura, *Art and Faith: A Theology of Making* (New Haven, CT: Yale University Press, 2021), 7.

9    ***"Why do I bother making things?":*** Alison Stine, "Why Art Matters, Even in Poverty," Talk Poverty, April 18, 2016, https://talkpoverty.org/2016/04/18/why-art-matters -even-in-poverty/index.html.

11    ***"Universal flourishing, wholeness, and delight":*** Cornelius Plantinga Jr., *Not the Way It's Supposed to Be: A Breviary of Sin* (Grand Rapids, MI: Eerdmans, 1995), 10.

## Chapter 1: Justice for the Maker

17 *The art of quilting has gathered women:* Robyne Robinson, "Quilts That Embody the Legacy of Black America," National Gallery of Art, March 17, 2023, https://www.nga.gov/stories/quilts-embody-legacy -black-america.html.

17 *Quilt of the Month newsletter:* "Quilt of the Month," newsletter, International Quilt Museum, University of Nebraska-Lincoln,https://www.internationalquiltmuseum. org/about/quilt-month, accessed May 24, 2024.

19 *"Spreading the embroidered quilt":* "Quilt, Kantha Art of Bengal," Mrs. E. M. Milford's translation of Jasim Uddin's poem *The Field of the Embroidered Quilt*, http://sos-arsenic.net/lovingbengal/quilt.html#3.

19 *Quilting involves the senses:* Jessica Gardner, "Quilting a Connection: The Use of Quilting in Group Art Therapy to Promote Well-Being for Older Women," August, 2016, https://core.ac.uk/download/pdf/211519171.pdf.

19 *"Quiltings were both labor and leisure activity":* Deanna Parenti, "The Stories behind African American Quilts," accessed May 22, 2024, https://www.artshelp.com/the -stories-behind-african-american-quilts/.

21 *"The act of cloth being re-purposed":* Floria Barnett Cash, "Kinship and Quilting: An Examination of an African-American Tradition," *Journal of Negro History* 80 (January 1, 1995): 30–41, https://www.semanticscholar.org/paper /Kinship-and-Quilting%3A-An-Examination-of-an -Cash/3c0e5d2e52738590e6f92c3a53d372d0855ea1ed.

21 *"Your writing voice is the deepest":* Meg Rosoff, "How to Write Fiction: Meg Rosoff on Finding Your Voice," *Guardian*, October 18, 2011, https://www

.theguardian.com/books/2011/oct/18/how-to-write -fiction-meg-rosoff.

22 **Quilting allows . . . quilters to explore:** Zanne Aroa, "Exploring Quilting as Self-Expression: The Voices of African American Quilters," Nancy's Notions, September 28, 2023, https://nancysnotions.com/exploring-quilting -as-self-expression-the-voices-of-african-american -quilters/.

23 **"a state in which people are so involved":** Mihály Cskikszentmihalyi, *Flow* (New York: Harper and Row, 1990), 4.

24 **Even facial muscles that enable:** Orjan de Manzano et al., "The Psychophysiology of Flow during Piano Play- ing," *Emotion* 10, no. 3 (2010): 301–31, https://doi.org /10.1037/a0018432.

24 **The repetitive nature of quilting:** Beth Cooper, "Did You Know Quilting Has Positive Health Benefits?" July 12, 2023, https://nancysnotions.com/did-you-know -quilting-has-positive-health-benefits/.

26 **What a journey to dignity and flourishing:** Parenti, "The Stories."

26 **Smith negotiated the price of this stunning quilt:** "Exploitation and Empowerment," International Quilt Museum, University of Nebraska–Lincoln, https:// worldquilts.quiltstudy.org/americanstory/identity/ exploitation-empowerment.

## Chapter 2: Justice for the Receiver

32 **receiving art correlated with good health:** Koenraad Cuypers et al., "Patterns of Receptive and Creative Cul- tural Activities and Their Association with Perceived

Health, Anxiety, Depression and Satisfaction with Life among Adults: the HUNT Study, Norway," *Journal of Epidemiological Community Health* 66, no. 8 (August 2012): 698–703, https://doi.org/10.1136/jech.2010.113571.

33 *"this is accompanied by a release of dopamine":* Teresa Nowakowski, "See What Your Brain Does When You Look at Art," *Smithsonian Magazine*, November 15, 2023, https://www.smithsonianmag.com/smart-news/this -headset-shows-you-what-your-brainwaves-do-when -you-look-at-art-180983261/.

34 *At first, nursing was agony:* Rebecca McLaughlin, "How Breastfeeding Changed My View of God," The Gospel Coalition, May 24, 2018, https://www .thegospelcoalition.org/article/breastfeeding-changed -view-god/.

35 *"model of redemptive looking":* Elissa Yukiko Weichbrodt, *Redeeming Vision: A Christian Guide at Looking at and Learning from Art* (Grand Rapids, MI: Baker Academic, 2023), 19.

36 *"We all just want to be called by the name":* Gregory Boyle, *Tattoos on the Heart: The Power of Boundless Compassion* (Los Angeles: Free Press, 2021), 60.

## Chapter 3: Justice for the Community

41 *Justice seeks to bring order as well:* Thomas Aquinas, *Summa Theologica* (Einsiedeln: Benziger Brothers, 1911), II.II 58, a. 1.

42 *"For the artist it's never enough":* Jed Perl, *Authority and Freedom: A Defense of the Arts* (New York: Knopf, 2021), 24.

43 *"The idea of 'culture care' is to seek to love":* Makato Fujimora and Susannah Black Roberts, "Making Art to

Mend Culture," *Plough*, December 5, 2023, https://www
.plough.com/en/topics/culture/making-art-to-mend
-culture.

44 **According to a 2023 report, 77 percent of influenc-
ers:** "Influencer Marketing Report 2023," *Collabstr*,
accessed May 24, 2024, https://collabstr.com/2023
-influencer-marketing-report.

46 **In 2019, the Facebook page "My Stealthy Freedom":**
Mireia Faro Sarrats, "The Role of Social Media in the
Fight for Women's Rights," accessed May 24, 2024,
https://www.iemed.org/publication/the-role-of-social
-media-in-the-fight-for-womens-rights/.

48 **"And then something like a smile":** Anna Akhmatova,
"Requiem," trans. Alex Cigale, *Hopkins Review* 9, no. 3
(summer 2016, New Series): 339.

48 **"Then I learned how faces fall apart":** Akhmatova,
"Requiem," 340.

48 **"To win a crowd is not art":** Søren Kierkegaard,
"Against the Crowd," *Plough Magazine*, 2017, excerpted
*from Provocations: Spiritual Writings of Søren Kierkeg-
aard* (Walden, NY: Plough Publishing House, 2014),
https://www.plough.com/en/topics/culture/holidays
/easter-readings/against-the-crowd.

49 **"The challenge for those of us who care about our
faith":** Katherine Paterson, official website, accessed
May 24, 2024, https://katherinepaterson.com/about
/faqs/.

50 **The nonprofit organization Freemuse's report:** Freemuse,
"State of Artistic Freedom 2023," 2023, https://freemuse
.org/media/cvajxuvr/saf-2023-compressed.pdf.

50 **In 2022, Iran became second:** "Freedom to Write
Index 2022," Pen America, accessed May 21, 2024,
https://pen.org/report/freedom-to-write-index-2022/.

52    ***At age fifty-one, having endured torture and solitary
      confinement:*** John Simpson, "White Torture by Narges
      Mohammadi Review—Solitary Savagery," *Guard-
      ian*, December 16, 2022, https://www.theguardian
      .com/books/2022/dec/16/white-torture-by-narges
      -mohammadi-review-solitary-savagery.

53    ***Greater equity was the central consideration:***
      Raisa Bruner, "Why Taylor Swift Is Recording Old
      Albums," *TIME*, October 27, 2023, https://time.com
      /5949979/why-taylor-swift-is-rerecording-old-albums/.

## Chapter 4: A Brutal, Exclusive Market

58    ***"If you know the enemy and know yourself":*** Sun
      Tzu, *The Art of War*, 1910, https://en.wikisource
      .org/wiki/The_Art_of_War_(Sun), accessed May 24,
      2024.

59    ***"This is my letter to the World":*** Emily Dickinson,
      "This Is My Letter to the World," accessed May 24, 2024,
      https://www.brinkerhoffpoetry.org/poems/this-is-my
      -letter-to-the-world.

66    ***"They teach a writer to rely on his own":*** Aerogramme's
      Writers Studio, "12 Famous Writers on Literary Rejection,"
      accessed July 31, 2024, https://www.aerogrammestudio
      .com/2013/06/15/12-famous-writers-on-literary
      -rejection/.

## Chapter 5: Destructive Interior Forces

71    ***If I'm wasting away in a maker's:*** Jimmy Buffett,
      "Wasting Away Again in Margaritaville," *Changes in
      Latitudes, Changes in Attitudes*, MCA records, track 6,
      1977.

73  *"the excessive and disordered desire":* Rebecca Konyn-dyk DeYoung, *Glittering Vices: A New Look at the Seven Deadly Sins and Their Remedies* (Ada, MI: Brazos Press, 2009), 60.

74  *"The proud person wants to be the director":* DeYoung, *Glittering Vices*, 63.

75  *"When I paint, I often tell myself":* Carol Aust, Personal Communication, September 25, 2023.

76  *"There is a God-shaped vacuum in the heart,":* Blaise Pascal, *Pensées* (Paris: Guillaume Desprez, 1670), https://www.gutenberg.org/files/18269/18269-h/18269-h.htm, Section 7, No. 425.

79  *You might have seen or heard:* Miloš Forman, *Amadeus* (Orion Pictures, 1984).

80  *"I found it possible to snatch a few precious days":* "Program Notes," Santa Fe Symphony, accessed May 22, 2024, https://santafesymphony.org/program-notes-romantic-legacies/.

83  *"The longer you leave your demons unchecked":* Richard Holman and Al Murphy, *Creative Demons and How to Slay Them* (London: Thames and Hudson Ltd., 2022), 10.

## Chapter 6: Restore Agency in the Vocation

91  *"Writers, composers, choreographers, painters":* Perl, *Authority and Freedom*, 26.

93  *The good news is that ten or fifteen minutes:* "What Is Flow and How Do You Achieve It?" Cigna General, October 2022, accessed July 31, 2024, https://www.cignaglobal.com/blog/body-mind/getting-into-a-flow-state-of-mind.

96   ***"Painters, Sculptors, and Architects are in danger":*** The Art Workers Guild, accessed May 24, 2024, https://www.artworkersguild.org/.

96   ***"We envision a vibrant and diverse movement":*** Redbud Writers' Guild, accessed May 24, 2024, https://redbudwritersguild.com/.

99   ***'The word used in Genesis 1 for* good*':*** Ned Bustard, *It Was Good: Making Art to the Glory of God* (Baltimore: Square Halo Books, 2007), 19.

## Chapter 7: Find Third Places

102   ***"The bent photograph is famous":*** Naomi Shihab Nye, "Famous," accessed July 31, 2024, https://www.poetryfoundation.org/poems/47993/famous.

102   ***Some of the characteristics Oldenburg uses:*** Ray Oldenburg, *The Great Good Place* (Cambridge, MA: Da Capo Press, 1989).

104   ***No matter the setting, third places are recognized:*** Morgan Kasprowicz, "Third Place Theory and Virtual Platforms: How Arts Organizations Might Build Community Online," Arts Management and Technology Laboratory at Carnegie-Mellon, November 17, 2020, https://amt-lab.org/blog/2020/11/building-online-community-third-place-theory-virtual-platforms.

104   ***"Interestingly, some research . . . suggests that the freedom to engage":*** Kasprowicz, "Third Place Theory."

107   ***"Every now and then an individual or group of individuals":*** "First Thoughts about Localism," Reformed Classicalist, August 2018, https://www.reformedclassicalist.com/home/first-thoughts-about-localism.

## Chapter 8: Seek Mentors in the Margins

113 ***Each is designed by the maker:*** Here's a brief video featuring some of these baskets: https://youtu .be/2v-cPZmhLG4?si=gpjAUC-KYNrfqBzS.

115 ***"Less than 25 percent of produced plays":*** Jane Chu, "Women in the Arts: Galvanizing, Encouraging, Inspiring," *American Artscape*, 2018, no. 1, https://www .arts.gov/stories/magazine/2018/1/women-arts -galvanizing-encouraging-inspiring.

116 ***Their craft was almost extinguished:*** Yulia Denisyuk, "From the Ashes: Rwanda's Traditional Imigongo Art Is on the Rise," *AFAR*, July 8, 2019, https://www .afar.com/magazine/from-the-ashes-rwandas-traditional -imigongo-art-is-on-the-rise.

119 ***These artists, using black ink:*** "Ancient Christian Scroll from Time of Persecution on Display in Yokohama," PIME Asian News, December 23, 2018, https://www .asianews.it/news-en/Ancient-Christian-scroll-from -time-of-persecution-on-display-in-Yokohama-45642 .html.

119 ***You can peruse this piece of art:*** Here is the piece on display in Yokohama: https://www.heraldmalaysia .com/uploads/news/2018/12/19940027981543942284 .jpg.

120 ***"She is being punished for being":*** Lucy Knight, "Imprisoned Uyghur Academic Named 2023 PEN Writer of Courage," *The Guardian*, October 11, 2023, https://www.theguardian.com/books/2023/oct/11 /imprisoned-uyghur-academic-named-2023-pen -international-writer-of-courage.

122 ***Renoir found new ways to hold:*** Emily Urquhart, "How Creativity Changes as We Age," *The Walrus*, May 28, 2021,

https://thewalrus.ca/older-wiser-better-aging-artists-are
-at-their-peak/.

## Chapter 9: Lean into Ancient Practices

126 **when I recommend The Unexpected Friend:** "Social
Justice Storytelling: Rohingya Refugee Humanitarian
Crisis," Guba Books, June 20, 2019, https://gubabooks
.com/blogs/blog/social-justice-storytelling-rohingya
-refugee?_pos=1&_sid=e0ad64048&_ss=r.

127 ***As* School Library Journal *put it in a glowing
review:*** Debbie Tanner, "The Unexpected Friend: A
Rohingya Children's Story," *School Library Journal*,
November 1, 2020, https://www.slj.com/review/the
-unexpected-friend-a-rohingya-childrens-story.

127 ***Save the Children's Rohingya Relief Fund:*** "Rohingya
Crisis," Save the Children, accessed May 24, 2024, https://
www.savethechildren.net/what-we-do/emergencies
/rohingya-crisis.

130 ***"The Lord often humbles the vainglorious":*** St. John
Climacus, "Vainglory and Pride," in *The Ladder of Divine
Ascent* trans. Norman Russell and Colm Luibheid (Saint
Catherine: Saint Catherine's Monastery, 600), 116.

131 ***"act of penitential courage":*** This podcast series by
Father Timothy Gallagher has been immensely help-
ful for me as an artist: https://www.discerninghearts
.com/catholic-podcasts/sd2-a-brief-overview-of-rules-1
-through-9-spiritual-desolation-be-aware-understand
-take-action-with-fr-timothy-gallagher-discerning
-hearts-podcast/.

131 ***Saint Ignatius's* Fourteen Rules of Spiritual Dis-
cernment:** Saint Ignatius of Loyola, "14 Rules

for the Discernment of Spirits," August 3, 2018, https://scepterpublishers.org/blogs/scepter-blog-corner /14-rules-for-the-discernment-of-spirits-by-st-ignatius -of-loyola.

135 ***"Great art comes from great pain":*** Christopher Zara, *Tortured Artists* (New York: Simon and Schuster, 2012), book jacket.

136 ***"To discover something from a moment of joy":*** Victoria Ford, "Great Art Comes Only from Those Willing to Be Vulnerable," ArtsBlog, Americans for the Arts, June 29, 2012, https://blog.americansforthearts.org/2019/05/15/great -art-comes-only-from-those-willing-to-be-vulnerable.

136 ***"The people who wade into discomfort":*** Brené Brown, "Courage over Comfort," March 13, 2018, https:// brenebrown.com/articles/2018/03/13/courage-comfort -rumbling-shame-accountability-failure-work/.

137 ***"So ensure that this ache wasn't endured in vain":*** Amanda Gorman, "The Miracle of Morning," April 2020, https://www.pbs.org/newshour/arts/amanda-gormans -poetic-answer-to-pandemic-grief-do-not-ignore-the -pain.

137 ***"for in truth, all other sins":*** Geoffrey Chaucer, "Parson's Tale," *The Canterbury Tales*, Harvard's Geoffrecy Chaucer, accessed August 1, 2024, https://chaucer.fas .harvard.edu/pages/parsons-prologue-and-tale.

139 ***"the magnanimous soul embraces the good":*** Anthony Esolen, "What Dante Can Teach Us about Envy," *Catholic Answers Magazine*, November 1, 2009, https://www .catholic.com/magazine/print-edition/what-dante-can -teach-us-about-envy.

141 ***"Because it is a distortion of being":*** Paulo Freire, *Pedagogy of the Oppressed* (New York and London: Continuum, 2005), 42, https://envs.ucsc.edu/internships

/internship-readings/freire-pedagogy-of-the-oppressed
.pdf.

142 ***"Our bad anger thus shows us"***: DeYoung, *Glittering Vices*, 134.

143 ***"In art there are only two"***: Paul Gauguin, "Letter in Le Soir," April 25, 1895, in Daniel Guérin, ed., *The Writings of a Savage*, trans. Eleanor Levieux (New York: Paragon House, 1990).

145 ***Track your habits to encourage progress:*** For more on Clear's laws of behavior change, see James Clear, *Atomic Habits* (New York: Avery Publishing, 2018).

146 ***When we return to work after a day of resting:*** https://www.charlesleon.uk/blog/do-nothing-and-increase-your-creative-thinking2212021.

## Chapter 10: Cross Borders and Liberate the Work

153 ***"It is a joy to be allowed"***: Madeleine L'Engle, *Walking on Water: Reflections on Faith and Art* (New York: Penguin Random House, 2016), 163.

154 ***"Each work of art"***: L'Engle, *Walking on Water*, 8.

154 ***"But the decision to reject doing"***: Perl, *Authority and Freedom*, 145–46.